IMPRESSIONS of

SOUTH AFRICA

Produced by AA Publishing

© Automobile Association Developments Limited 2008

All rights reserved. No part of this publication may be reproduced, stored in
a retrieval system, or transmitted in any form or by any means – electronic,
photocopying, recording or otherwise – unless the written permission of the
publishers has been obtained beforehand.

Published by AA Publishing (a trading name of Automobile Association
Developments Limited, whose registered office is Fanum House, Basing View,
Basingstoke, Hampshire RG21 4EA; registered number 1878835)

ISBN: 978-0-7495-5860-4

A03676

A CIP catalogue record for this book is available from the British Library.

The contents of this book are believed correct at the time of printing. Nevertheless,
the publishers cannot be held responsible for any errors, omissions or for changes in
the details given in this book or for the consequences of any reliance on the
information provided by the same. This does not affect your statutory rights.

Colour reproduction by KDP, Kingsclere

Printed and bound in China by C & C Offset Printing Co. Ltd

Opposite: A yellow-billed hornbill perched on top of a thorn tree in Kruger National Park, one of over 500 species of birds recorded in the park

IMPRESSIONS *of*

SOUTH AFRICA

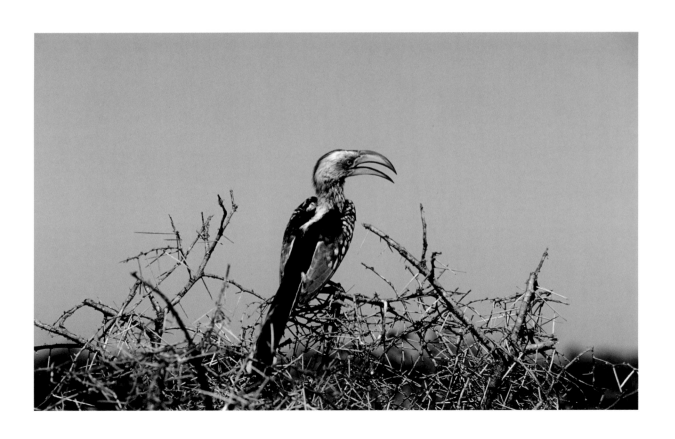

Picture Acknowledgements

The Automobile Association would like to thank the following photographers, companies
and picture libraries for their assistance in the preparation of this book.

Abbreviations for the picture credits are as follows: (AA) AA World Travel Library

3 AA/S McBride; 5 AA/C Sawyer; 7 AA/C Sawyer; 8 AA/M Birkitt; 9 AA/C Sawyer; 10 AA/P Kenward;
11 AA/P Kenward; 12 AA/P Kenward; 13 AA/P Kenward; 14 AA/P Kenward; 15 AA/C Sawyer;
16 AA/P Kenward; 17 AA/C Sawyer; 18 AA/C Sawyer; 19 AA/P Kenward; 20 AA/C Sawyer; 21 AA/C Sawyer;
22 AA/C Sawyer; 23 AA/P Kenward; 24 AA/C Sawyer; 25 AA/J Howard; 26 AA/P Kenward; 27 AA/C Sawyer;
28 AA/C Sawyer; 29 AA/C Sawyer; 30 AA/C Sawyer; 31 AA/P Kenward; 32 AA/P Kenward; 33 AA/C Sawyer;
34 AA/P Kenward; 35 AA/C Sawyer; 36 AA/J Howard; 37 AA/P Kenward; 38 AA/C Sawyer; 39 AA/P Kenward;
40 AA/C Sawyer; 41 AA/C Sawyer; 42 AA/C Sawyer; 43 AA/C Sawyer; 44 AA/P Kenward; 45 AA/C Sawyer;
46 AA/C Sawyer; 47 AA/C Sawyer; 48 AA/C Sawyer; 49 AA/P Kenward; 50 AA/C Sawyer; 51 AA/C Hampton;
52 AA/C Sawyer; 53 AA/S McBride; 54 AA/P Kenward; 55 AA/C Sawyer; 56 AA/C Hampton; 57 AA/C Sawyer;
58 AA/P Kenward; 59 AA/C Hampton; 60 AA/C Sawyer; 61 AA/C Sawyer; 62 AA/J Howard; 63 AA/S McBride;
64 AA/C Sawyer; 65 AA/C Sawyer; 66 AA/P Kenward; 67 AA/S McBride; 68 AA/C Sawyer; 69 AA/C Sawyer;
70 AA/C Sawyer; 71 AA/C Sawyer; 72 AA/C Sawyer; 73 AA/C Sawyer; 74 AA/C Sawyer; 75 AA/C Sawyer;
76 AA/C Sawyer; 77 AA/C Sawyer; 78 AA/C Sawyer; 79 AA/C Sawyer; 80 AA/C Sawyer; 81 AA/C Sawyer;
82 AA/C Sawyer; 83 AA/C Sawyer; 84 AA/C Sawyer; 85 AA/C Sawyer; 86 AA/C Sawyer; 87 AA/C Sawyer;
88 AA/C Sawyer; 89 AA/C Sawyer; 90 AA/C Sawyer; 91 AA/C Sawyer; 92 AA/C Sawyer; 93 AA/C Sawyer;
94 AA/C Sawyer; 95 AA/C Hampton.

Every effort has been made to trace the copyright holders, and we apologise in advance for any unintentional
omissions or errors. We would be happy to apply the corrections in any following edition of this publication.

Opposite: The Valley of Desolation in the Eastern Cape's Camdeboo National Park

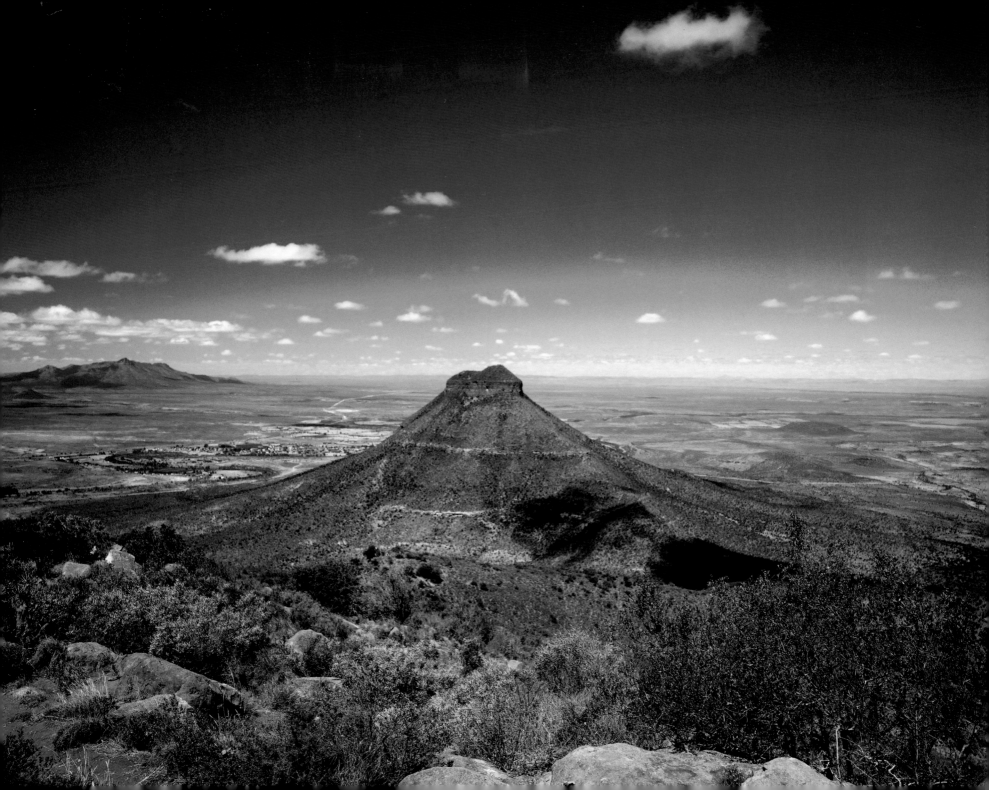

INTRODUCTION

South Africa combines incredible natural beauty with a wealth of varied landscapes. It's fringed by the warm tropical Indian Ocean coastline in the east, and pounded by the cool currents of the Atlantic to the west; both of which meet at Cape Agulhas, Africa's southernmost tip. The country is divided into nine provinces; each with its own character.

The Western Cape is a patchwork of farmland hemmed into scenic valleys, where the coast is dotted with picturesque towns and the ocean is alive with marine-life including whales, seals, sharks and penguins. The beautiful city of Cape Town is backed by brooding Table Mountain and a national park encompassing most of the Cape Peninsula. The historic wine estates offer wine-tasting and gourmet food and the Garden Route is a lush tract of forested coast studded with lagoons and nature reserves. The Eastern Cape features the game-rich Addo Elephant National Park, and the long expanse of verdant coastal forest and windswept dunes of the Wild Coast. The Northern Cape is home to the red dunes and parched wilderness of the Kalahari Desert, and Kimberley, the centre of South Africa's diamond industry.

KwaZulu Natal has the country's greatest diversity of landscapes, and here visitors can go on safari, hike through dramatic wilderness, surf the country's best beaches and experience South Africa's strongest African culture. Mountains in the Ukhahlamba-Drakensberg National Park soar to over 3000 metres, Zululand is rich in history, and the tropical coastline of Maputaland is an undisturbed wilderness, while the Battlefields still bear the scars of the Zulu and Boer wars.

Built on the richest gold reef in the world, the economic powerhouse and most populated province is Gauteng. Here, vibrant Johannesburg has sleek modern architecture, a tangle of highways, skyscrapers, townships, and hundreds of suburbs. By contrast Pretoria is conservative, with wide streets of sandstone buildings lined with jacaranda trees and has long been a centre for the Afrikaner community, attested to by the sombre Voortrekker Monument.

The North West Province is made up of flat Kalahari grasslands dotted with farming communities, and attractions include glitzy Sun City, a huge entertainment complex and one-time gambling haven, and the Pilanesberg National Park and Madikwe Game Reserve. Further north in Limpopo, the countryside opens into dry *bushveld* dotted with tubby *baobab* trees, while the Free State in the centre of the country is a sparsely populated prairie land, fringed by the Maluti Mountains in the east, which rise to meet the mountain kingdom of Lesotho, scattered with dams, streams and pretty rural villages.

In Mpumalanga is the magnificent Kruger National Park and the many private game reserves fringing its western border. Overlooking Kruger, the Eastern Drakensberg Escarpment is dotted with quiet agricultural towns, forests and waterfalls clustered along the top of the spectacular Blyde River Canyon.

Opposite: With its shops, restaurants and entertainment facilities, and ever-present views of Table Mountain, the Victoria and Alfred Waterfront is Cape Town's top attraction

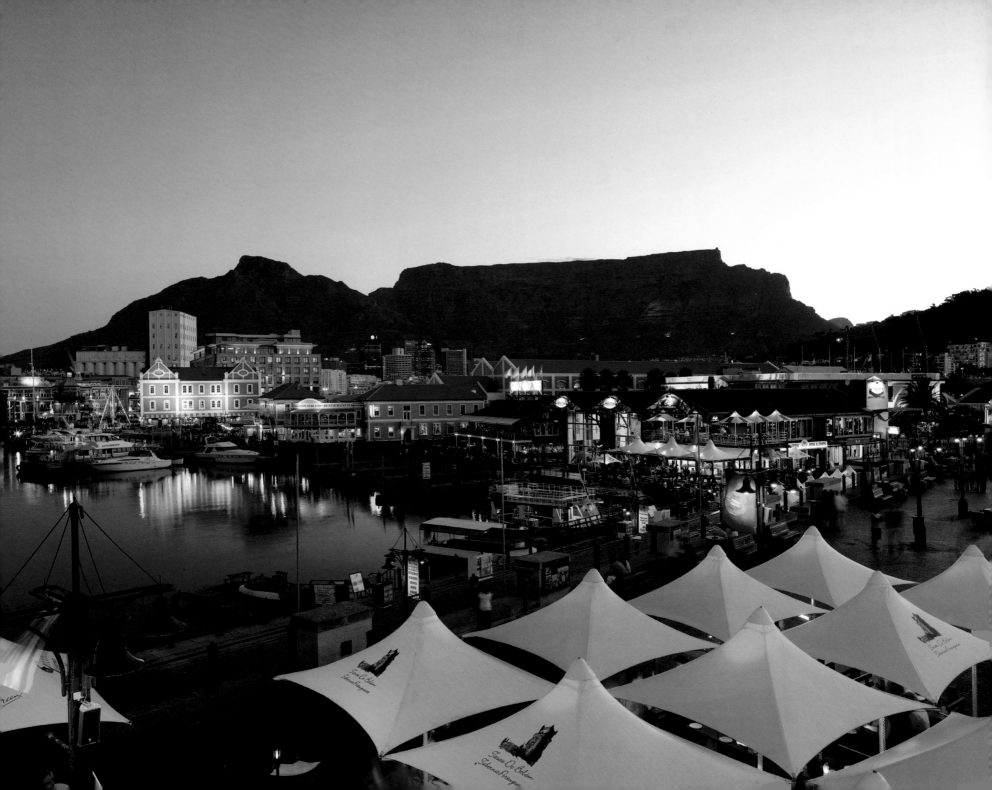

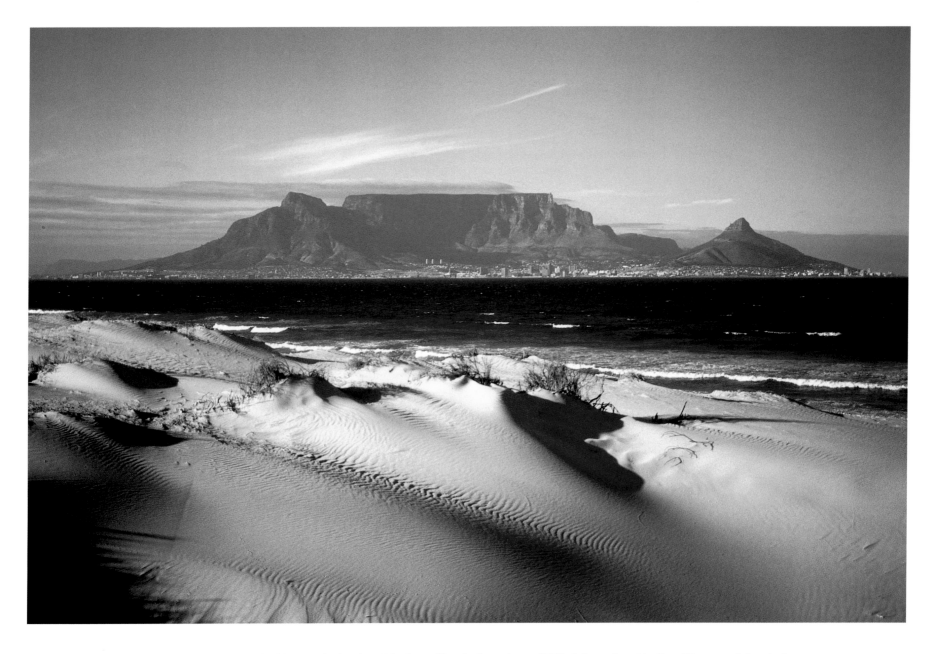

Lying on the west coast of Table Bay, the beach at Blouberg offers the best views of Table Mountain with Cape Town nestled at its base

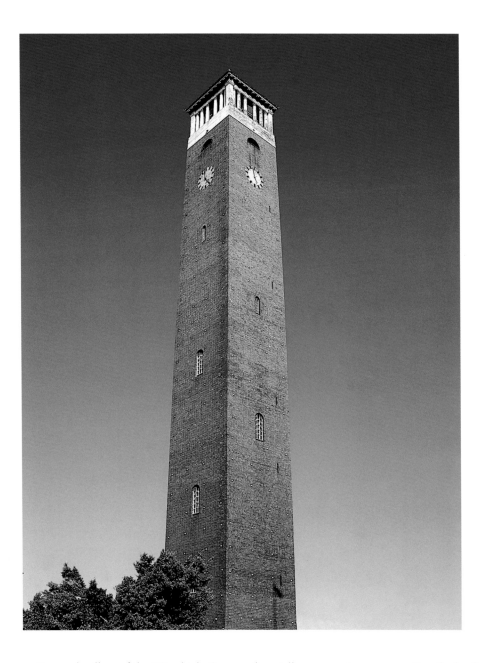

The upper portion and gallery of the 52m-high Campanile, a tall monument commemorating the landing of the 1820 settlers, built in the 1920s at the entrance to the docks at Fort Frederick in the town of Port Elizabeth

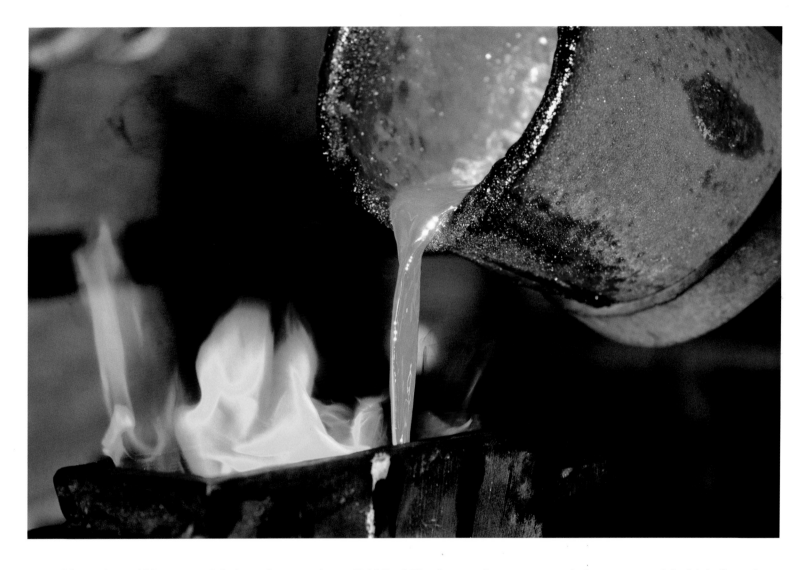

Red hot molten gold being poured during a demonstration at Gold Reef City theme park, a re-constructed pioneer town and funfair built on the site of one of Johannesburg's mining areas

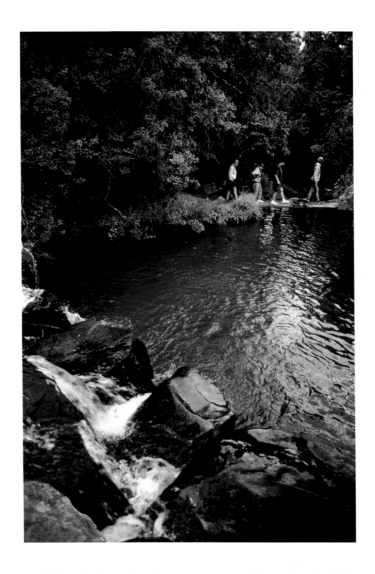

A group of hikers fording a broad stream by means of a wooden footbridge in the wooded foothills of the Drakensberg Mountains

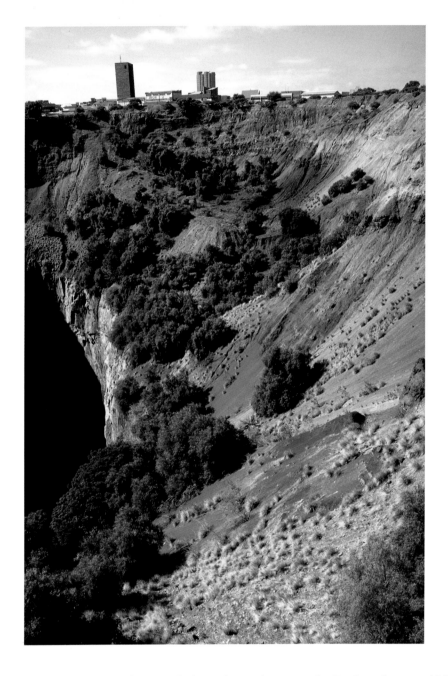

The almost sheer slopes of the Big Hole at Kimberley, a diamond mine run by De Beers between 1889 and 1914 and at 1,100 metres deep, the largest hand-dug hole in the world

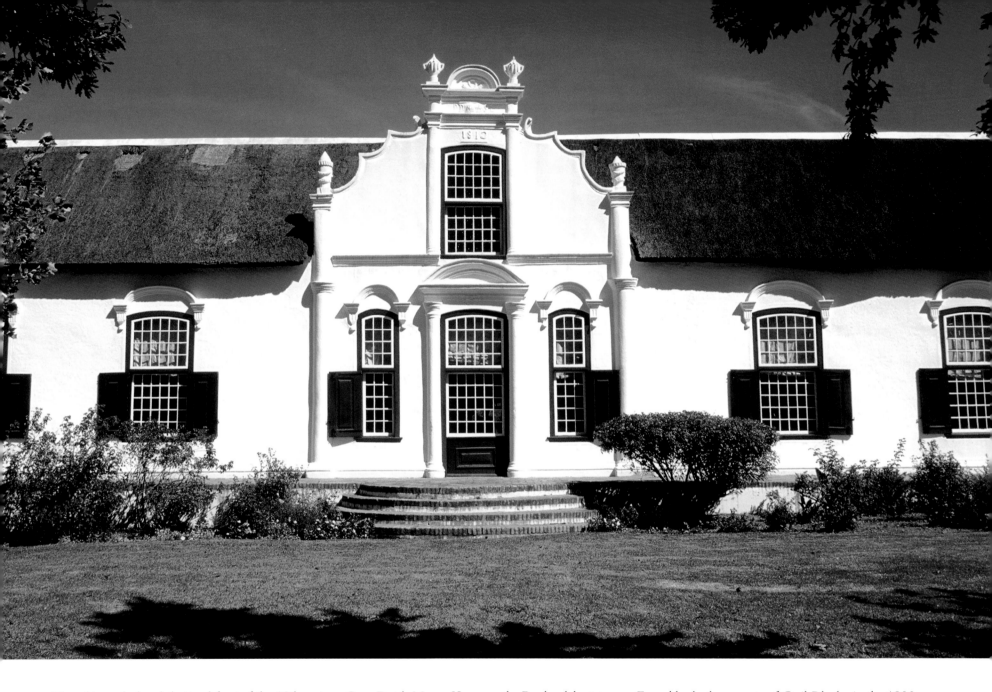

The whitewashed and shuttered front of the 18th-century Cape Dutch Manor House on the Boschendal estate near Franschhoek, the property of Cecil Rhodes in the 1890s

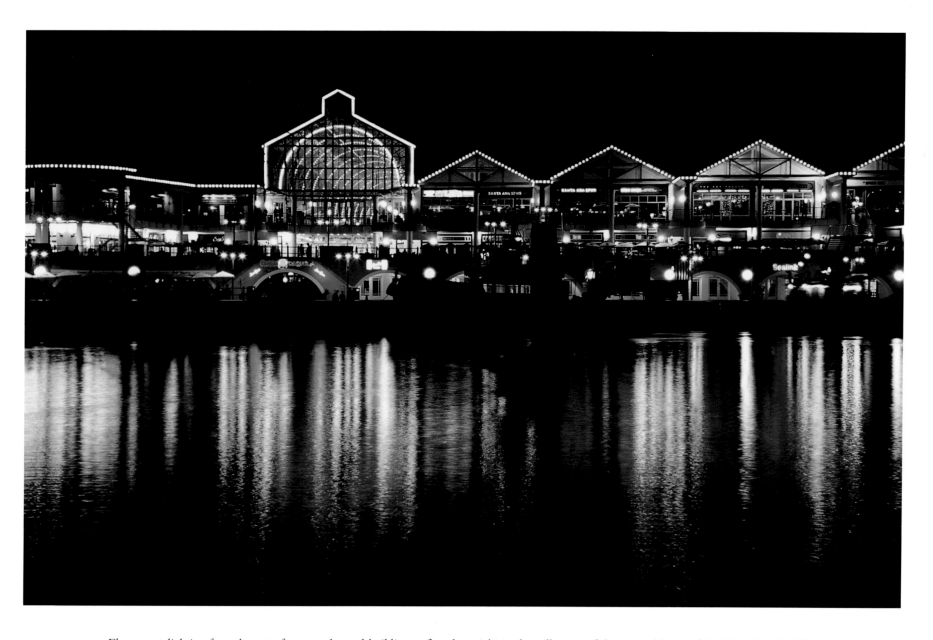

Fluorescent lighting from the waterfront arcades and buildings reflected at night in the still water of the original basin of the Victoria and Alfred docks in Cape Town's harbour complex

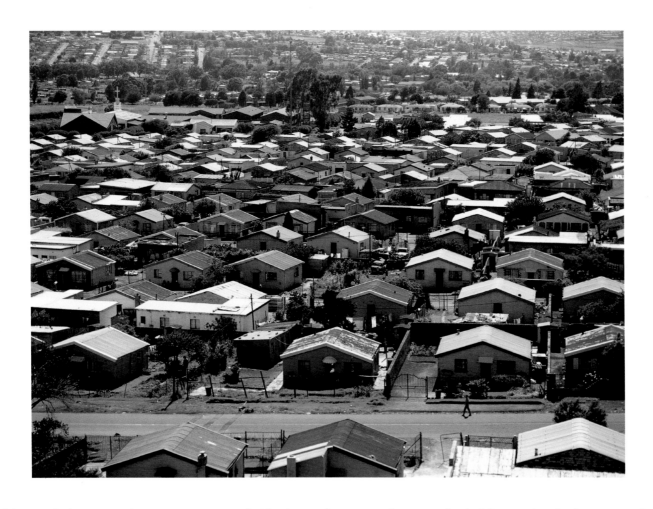

Colourful tin roofs gleaming in the sun in Soweto, South Africa's most famous township, once a hot bed for anti-Apartheid activism and today the most vibrant and cosmopolitan township in the country

A clump of pink flowers growing in the meadows sheltered by the Drakensberg Mountains

Algoa Beach, along Port Elizabeth's aptly named Sunshine Coast, a string of beaches celebrated for their soft sand, warm calm waters and long hours of sunshine

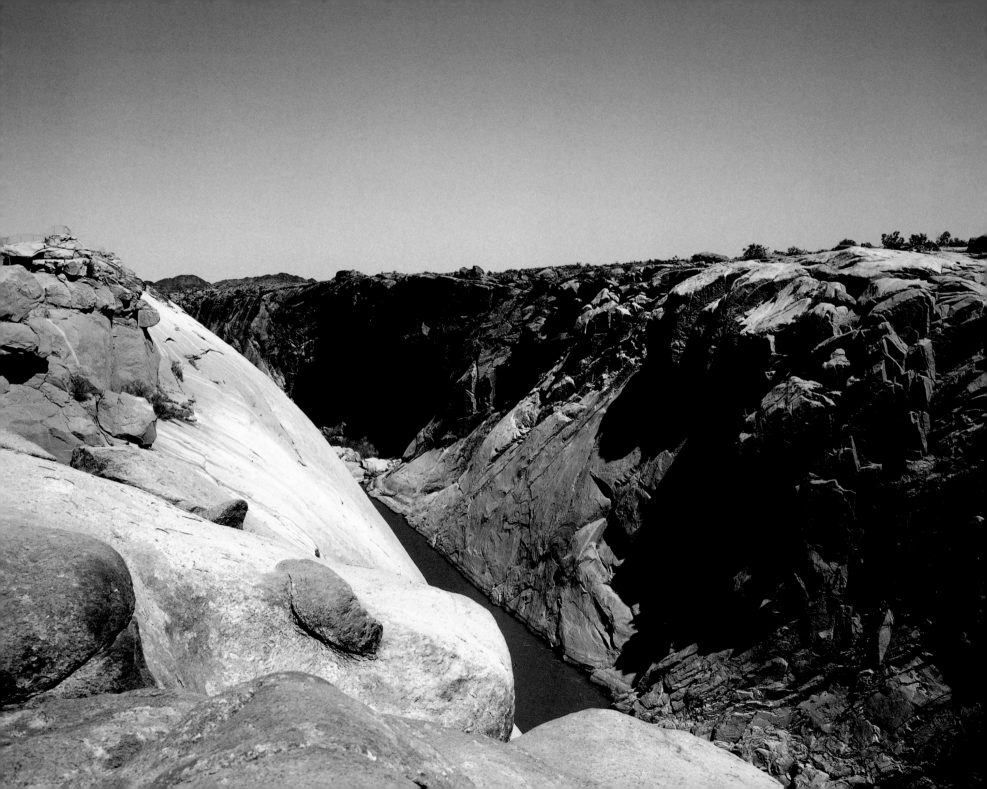

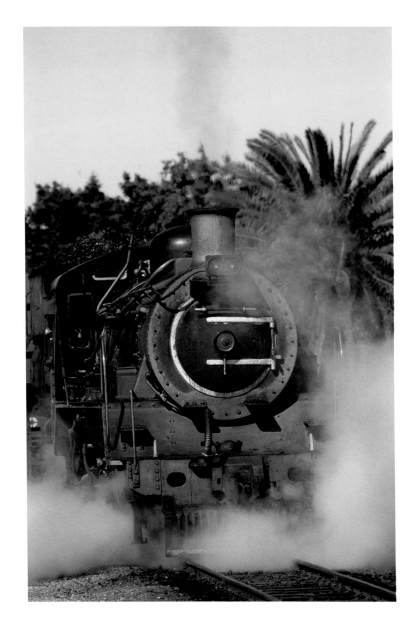

The engine of the historical Outeniqua Choo-Tjoe train emerging from a cloud of steam on the line between George and Mossel Bay on the Garden Route
Opposite: Steep, smooth rock faces plunging deep into the gorge where the Gariep (formerly the Orange) River flows into a series of dramatic waterfalls in the Augrabies Falls
National Park

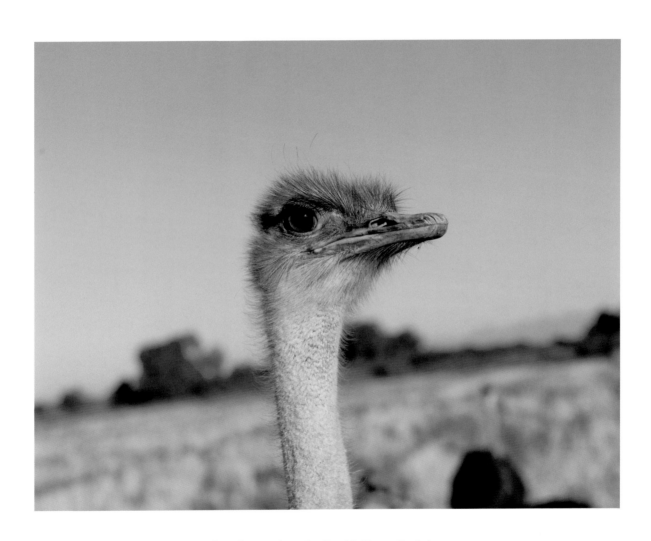

A friendly ostrich at the Ostrich Farm, Oudtshoorn

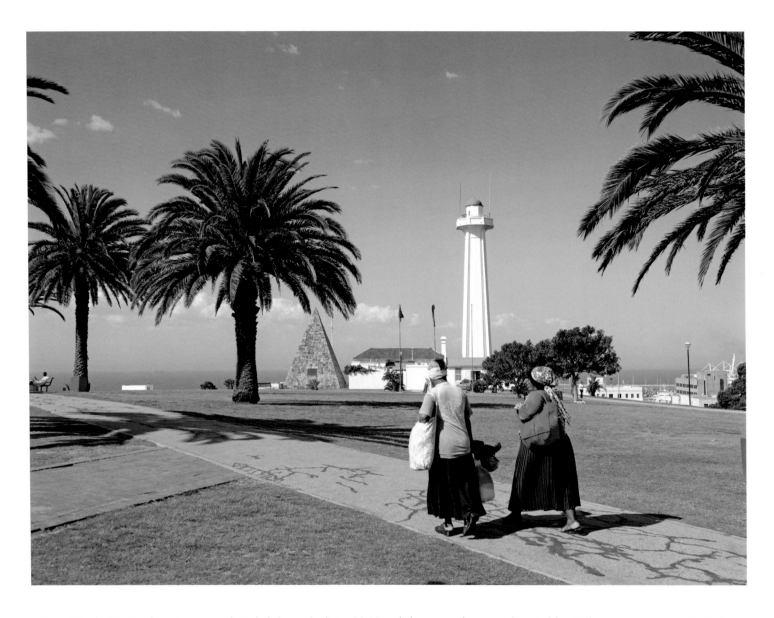

Port Elizabeth's Donkin Reserve with its lighthouse built in 1861 and the pyramid memorial erected by 19th-century governor Sir Rufane Donkin in memory of his wife Elizabeth, after whom the city was named

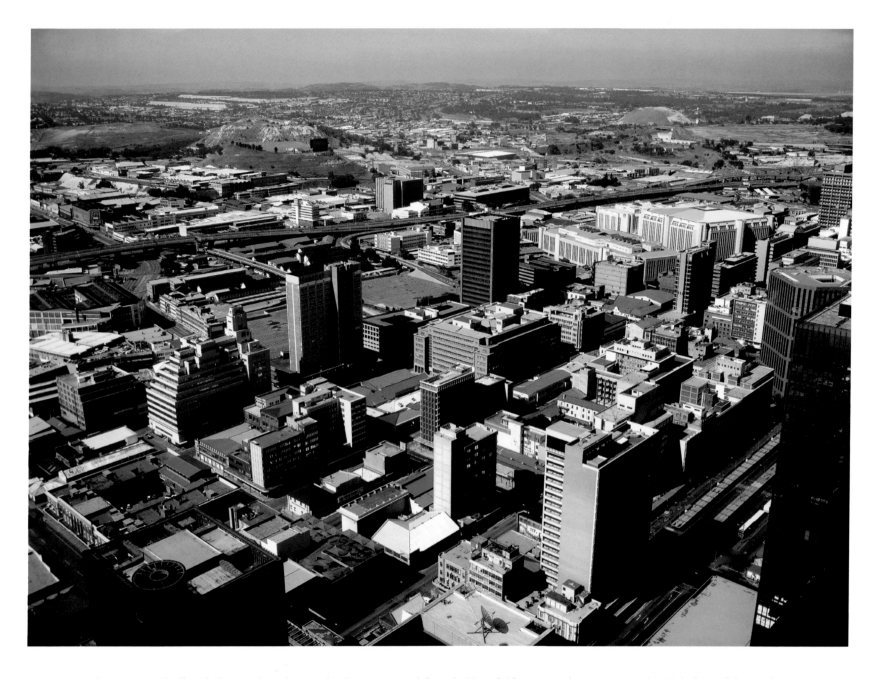

Skyscrapers and office blocks stretching far into the distance, viewed from the Top of Africa, a revolving tower on the 50th floor of the Carlton Centre, central Johannesburg's principal landmark which also houses a massive shopping centre

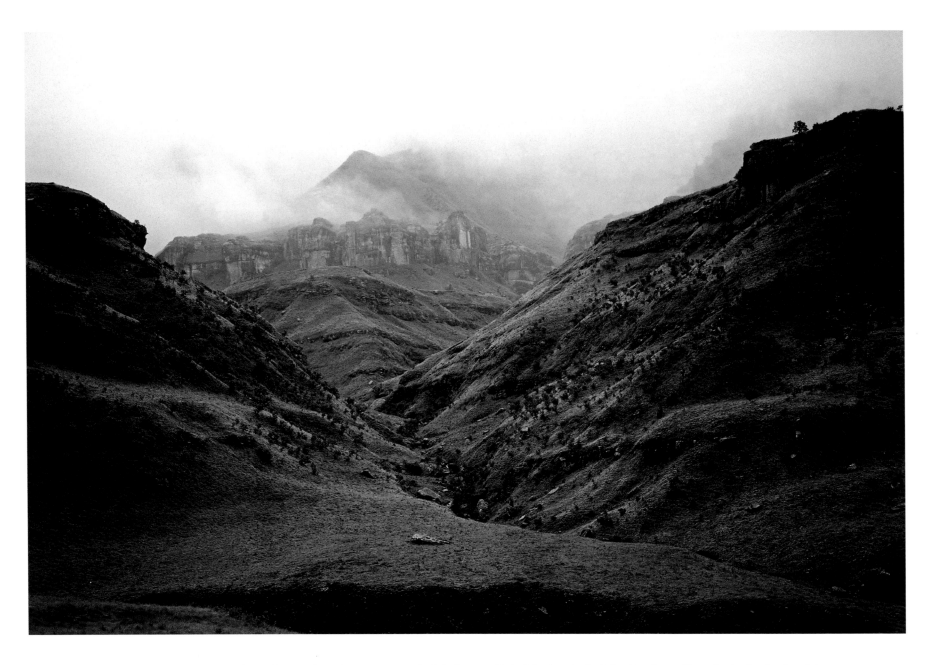

Low cloud hovering over the peaks guarding the Sani Pass, which links KwaZulu Natal with the lofty kingdom of Lesotho in the depths of the Drakensberg Mountains

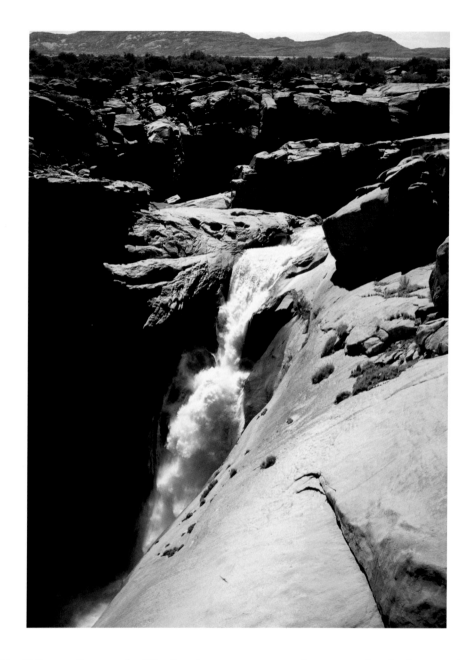

The Augrabies Falls cascading over the 56m drop into a narrow gorge of steep, smooth rock, the water churning below

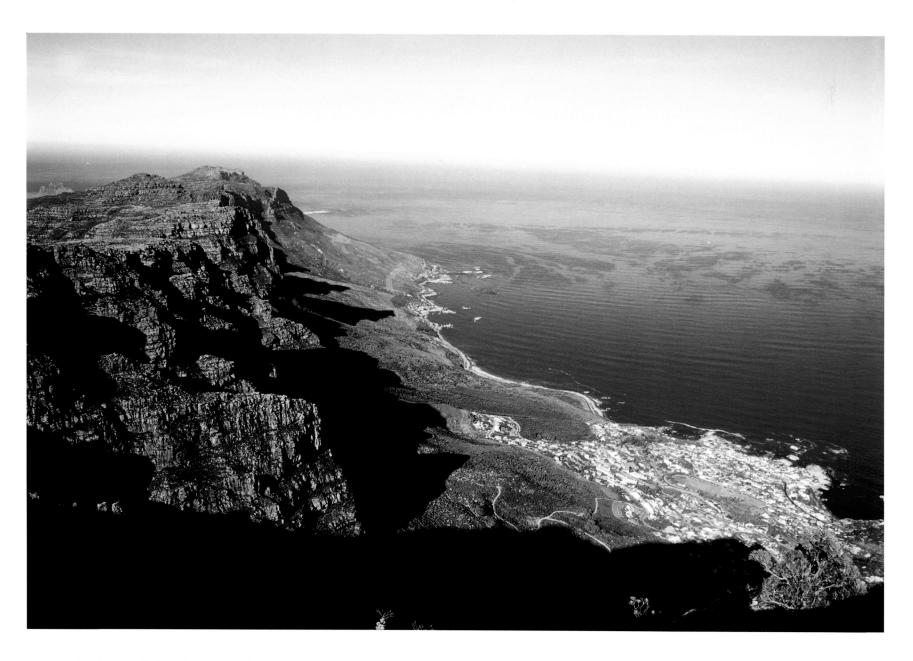

Looking south from the viewing platform on the level plateau at the summit of Table Mountain, the Atlantic and its coastline stretching into the distance

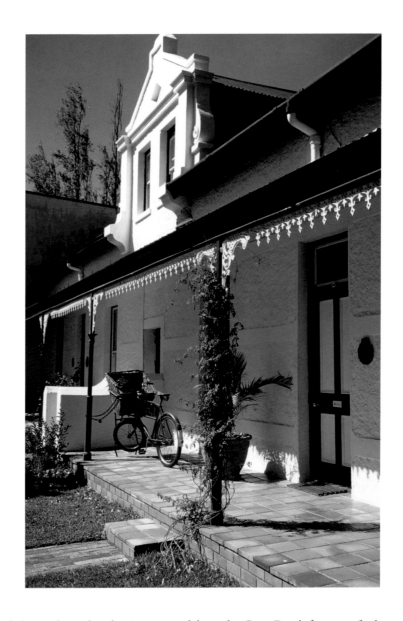

A tiled stoep beneath a decorative verandah on the Cape Dutch frontage of a house set in gardens in Dorp Street, Stellenbosch

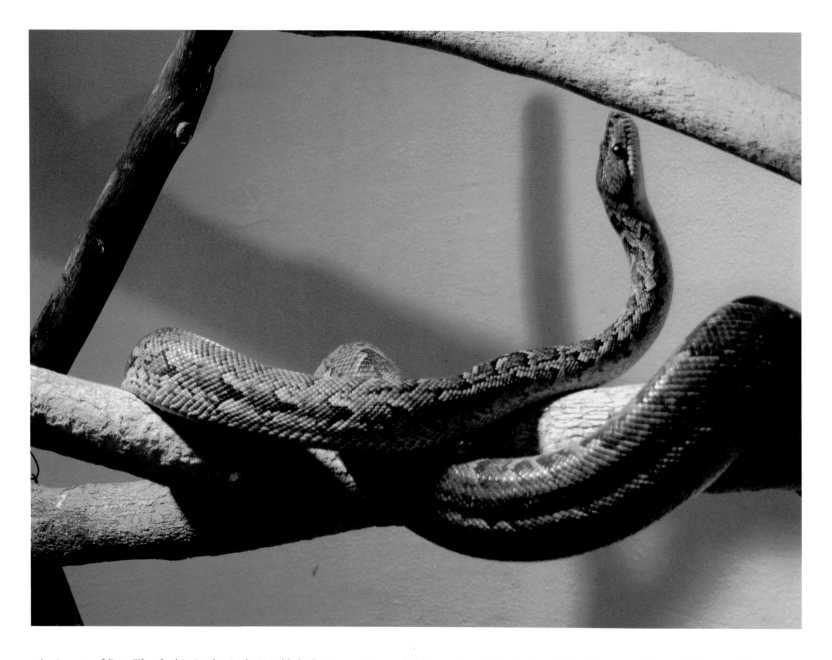

An inmate of Port Elizabeth's Snake Park. Established in 1919 it was the first snake park in Africa and is today part of Bayworld's string of attractions

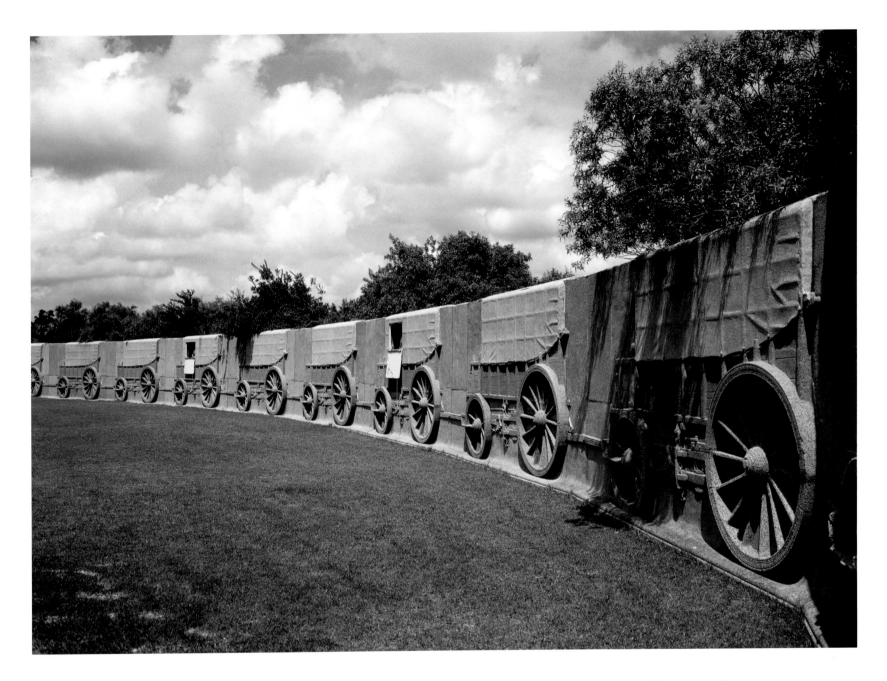

The circular laager of 64 ox-wagons commemorating the Great Trek of the Afrikaners during the 1830s, surrounding the Voortrekker Monument set on a hilltop to the south of the city of Pretoria

The ornate exterior of the Ostrich Palace, Oudtshoorn

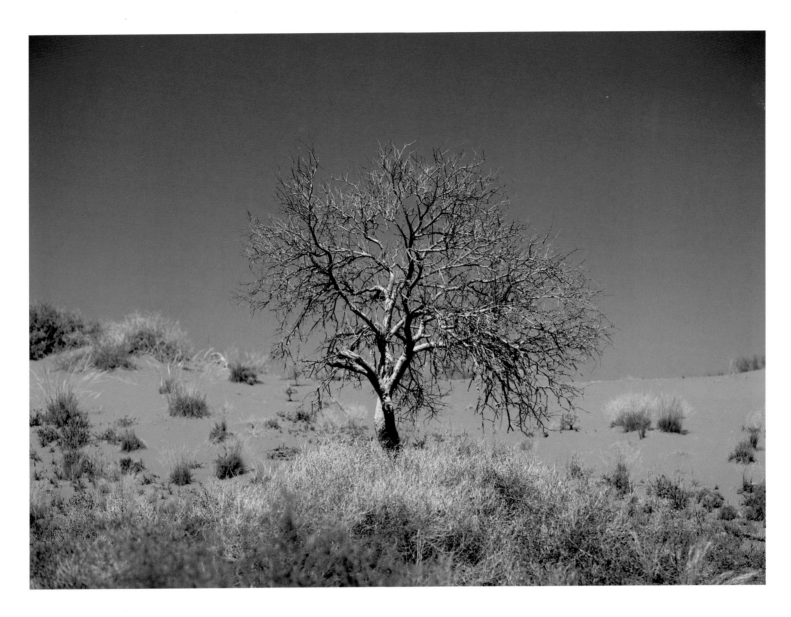

Sparse vegetation and a lone tree on the dunes, sharply etched against the deep blue skies of the Kalahari desert

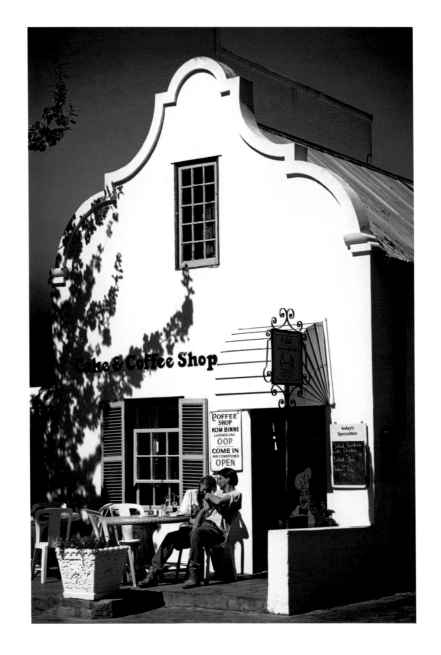

This old Cape Dutch building on Dorp Street in the oldest quarter of the Winelands
town of Stellenbosch serves cake and coffee to visitors

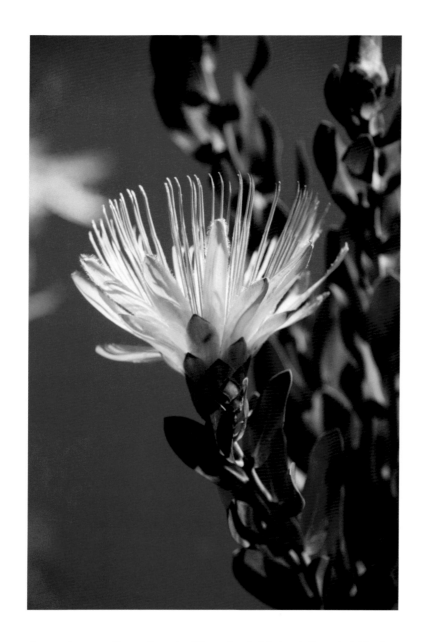

An exotic protea flower from the Kirstenbosch National Botanical Gardens

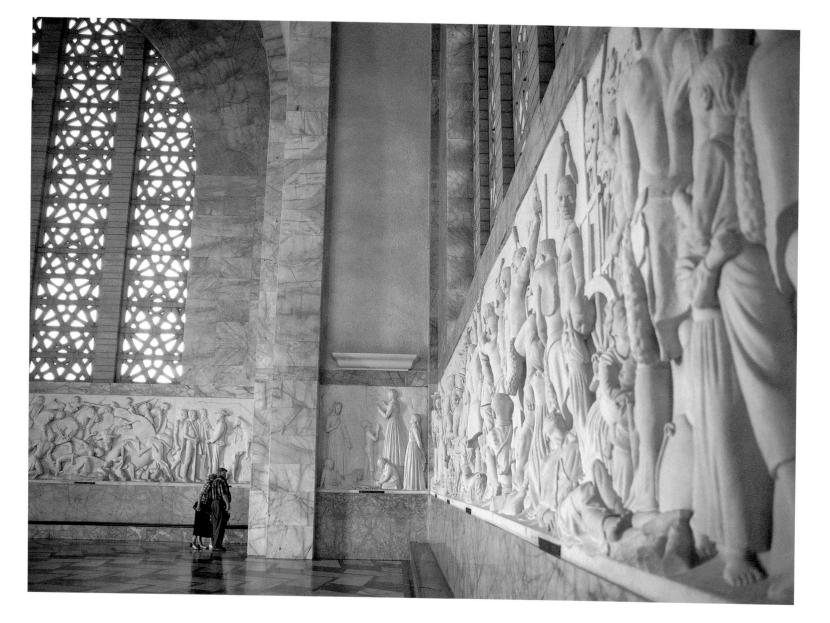

Sculpted friezes depicting and commemorating the Great Trek of 1838 in the Voortrekker Monument built in 1940 and located to the south of the city of Pretoria

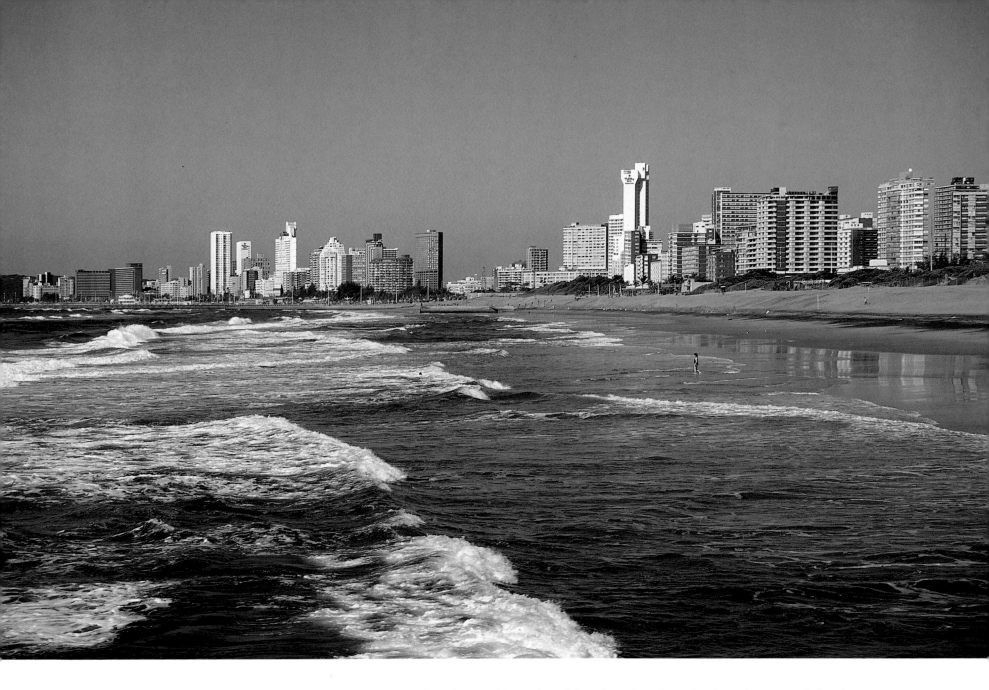

Tall skyscrapers fringing the pedestrianised length of Durban's Golden Mile, surf from the Indian Ocean breaking along its sandy length

Occasional trees and clumps of scrub on the red dunes, etched against the blue skies of the Kalahari desert, Northern Cape

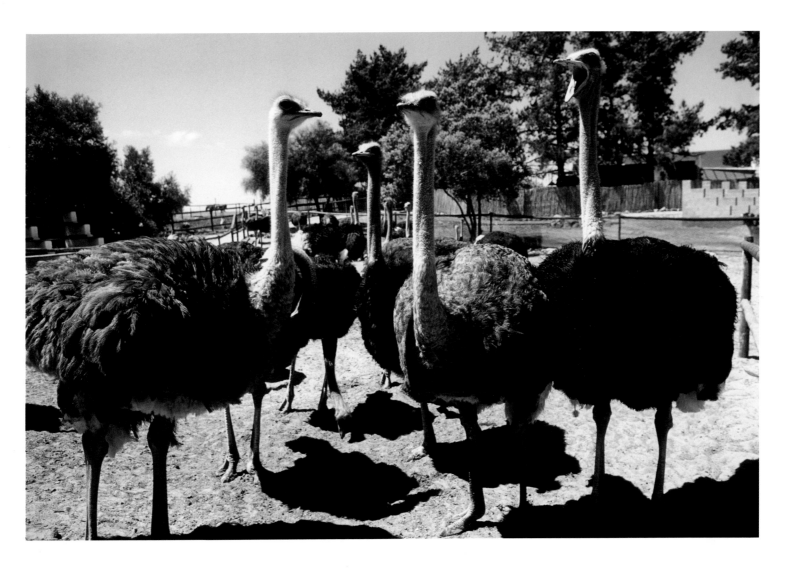

A group of ostriches on the farm at Oudtshoorn, where the fine sandstone buildings or 'ostrich palaces' were built during the 19th- and 20th-century ostrich-feather fashion booms

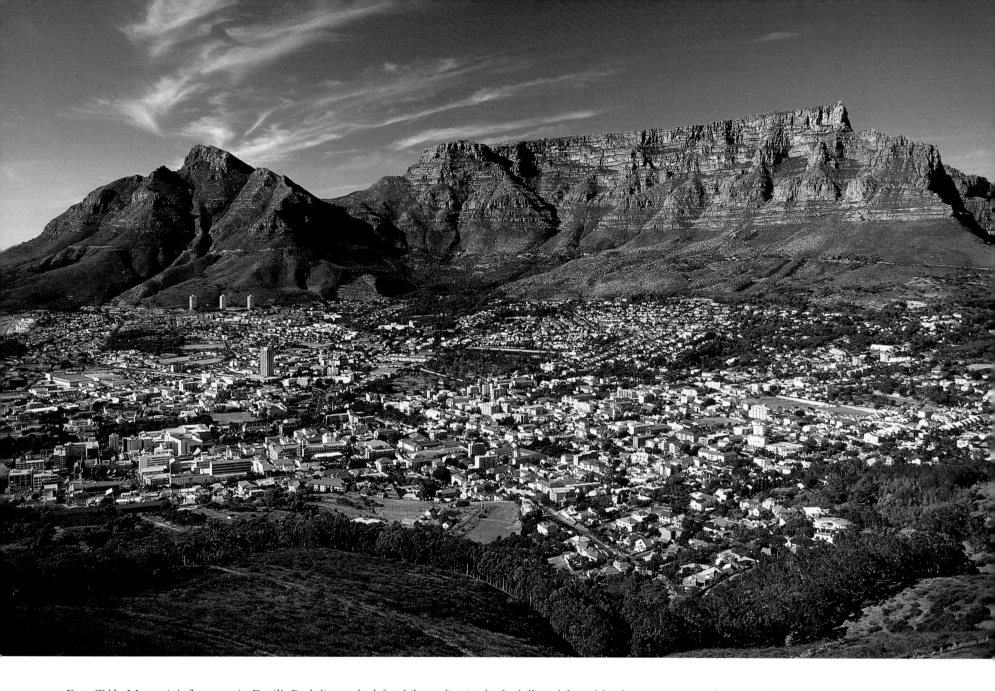

From Table Mountain's flat summit, Devil's Peak lies to the left, while nestling in the foothills and framed by the mountains are the clustered whitewashed homes of the suburbs of the City Bowl

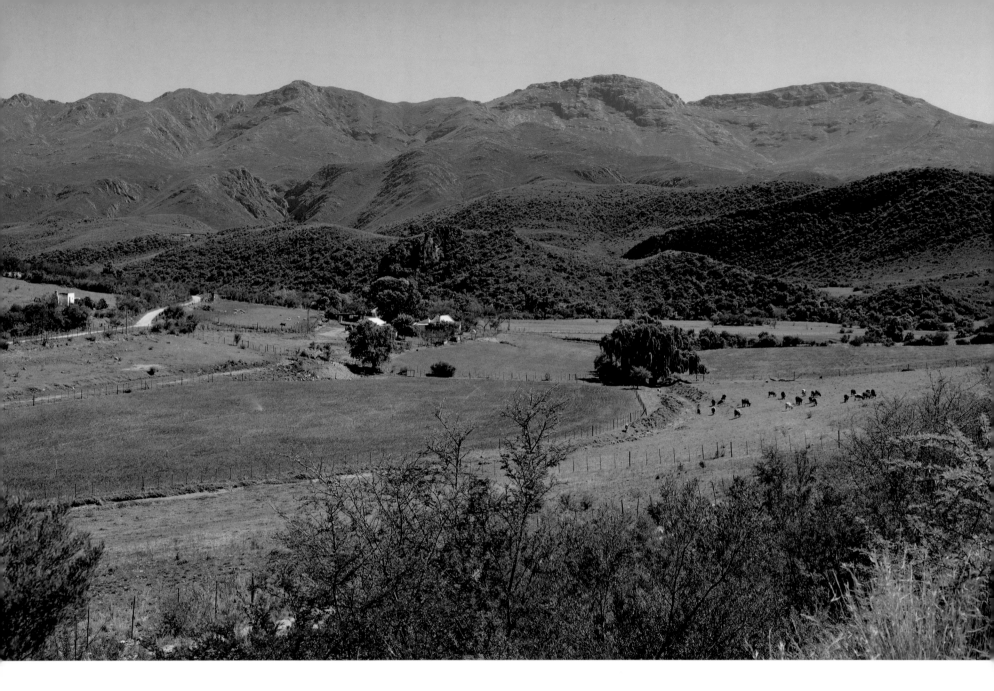

Lush green fields at Swartberg Pass, Oudtshoorn

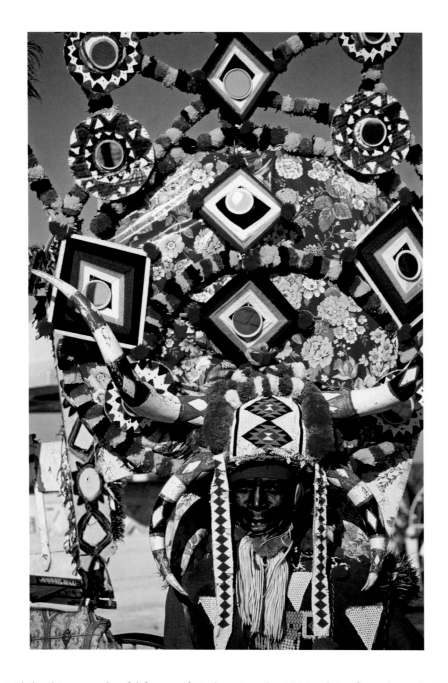

One of the Ricksha drivers, a colourful feature of Durban since the 1890s, plying for trade on the city's waterfront

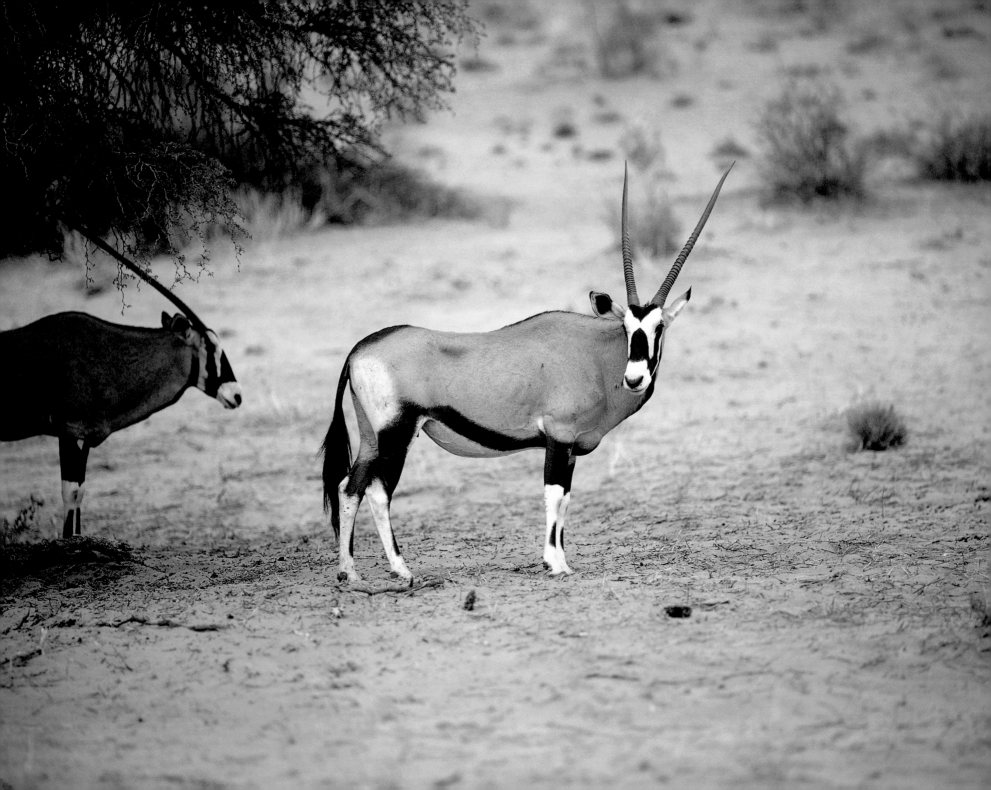

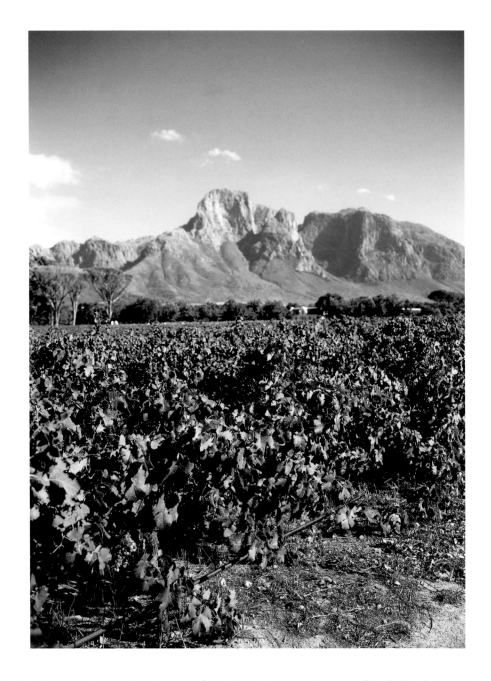

The encircling Hottentots Holland mountain range looming over flourishing vines near the town of Stellenbosch, centre of the South African Winelands
Opposite: Gemsbok in the Kgalagadi Transfrontier Park in the Northern Cape, one of Africa's largest and most striking antelopes with long spear-like horns

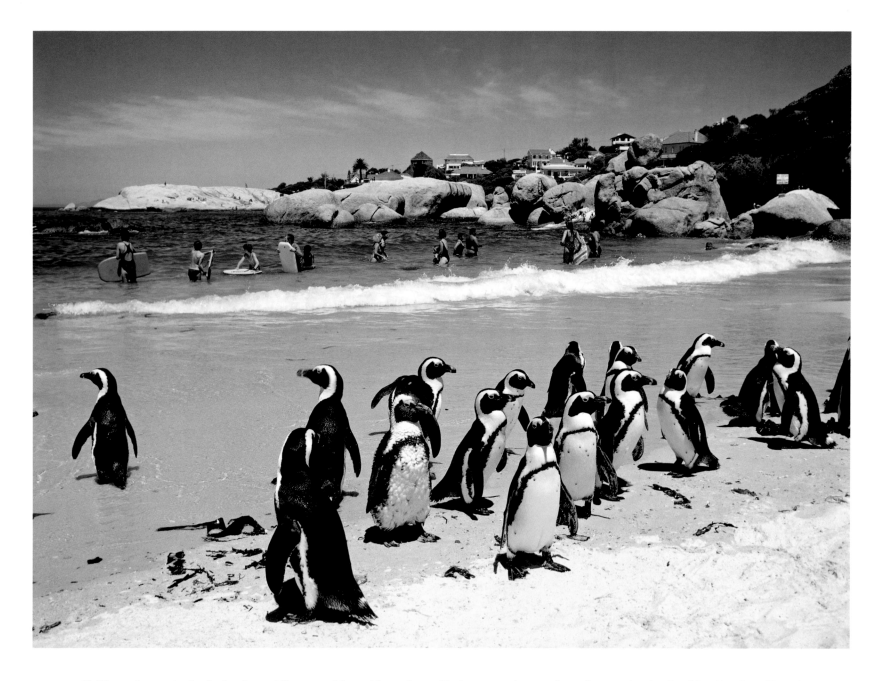

Holidaymakers swim in the breakers while some of the resident colony of jackass penguins sun themselves on the tiny Boulders Beach at Simon's Town on the eastern Cape Peninsula

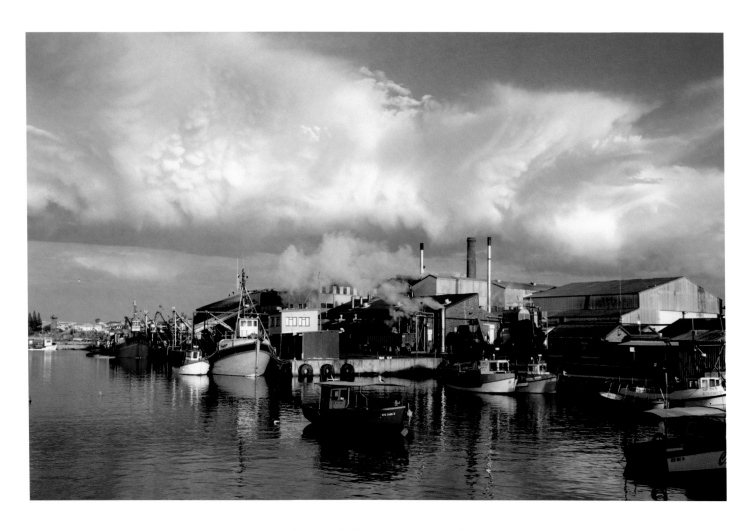

Fishing boats in the busy harbour at Lambert's Bay

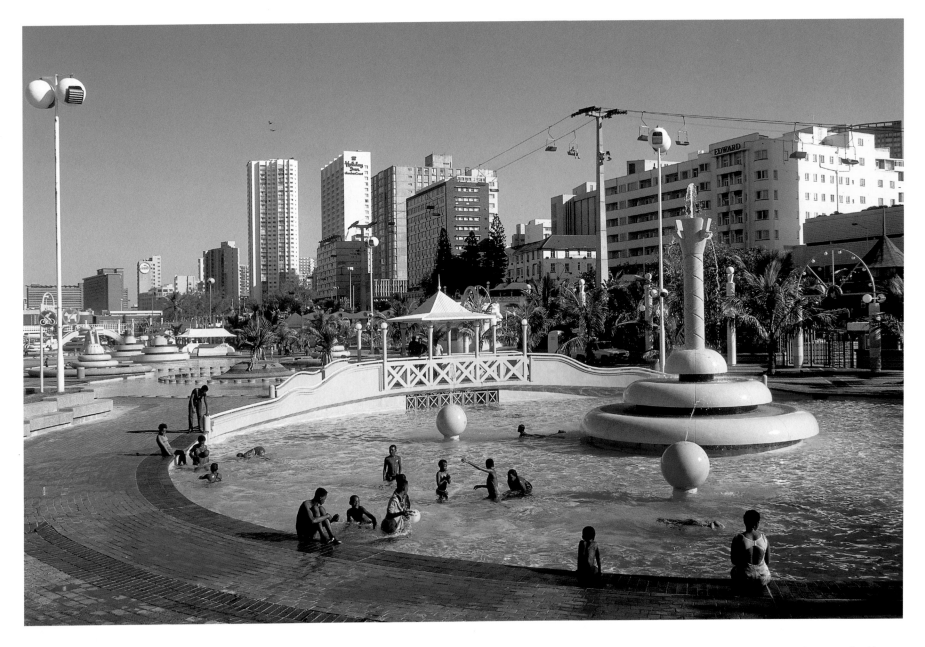

Durban beachfront, known as the Golden Mile, offers a string of attractions including paddling pools with stepping stones and bridges, amusement rides and an aerial cableway

Opposite: Cape gannets, playful inhabitants of the aptly named Bird Island, Lambert's Bay

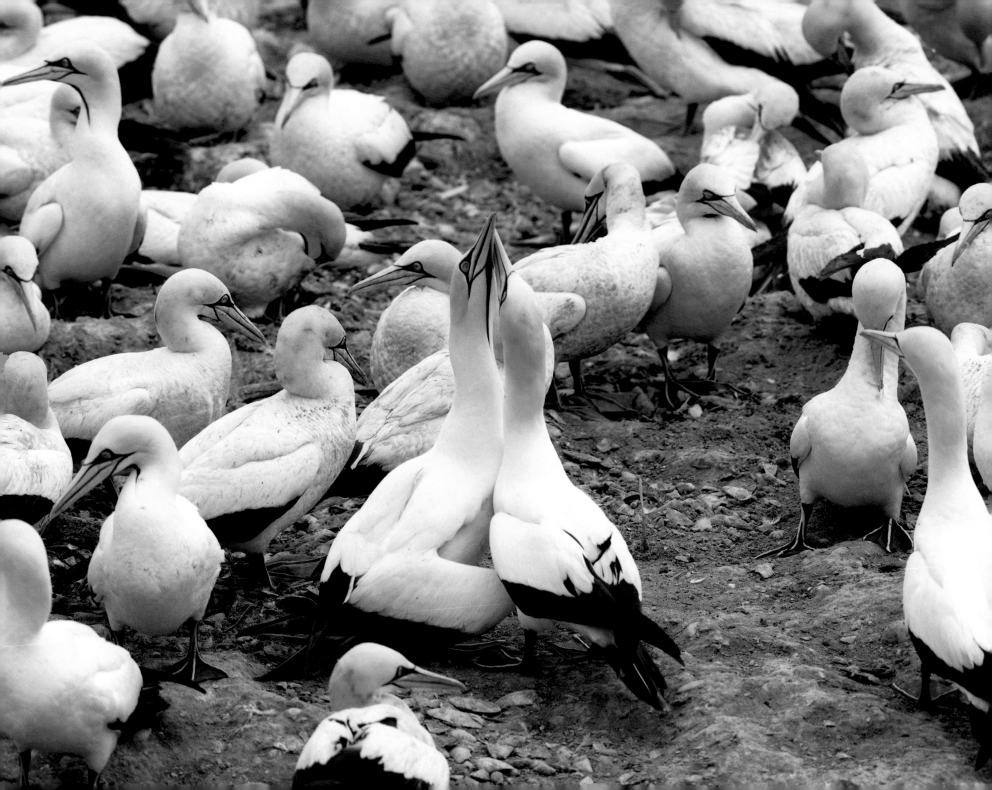

A portico enhancing a building in the historic town of Stellenbosch in the heart of the Cape Winelands

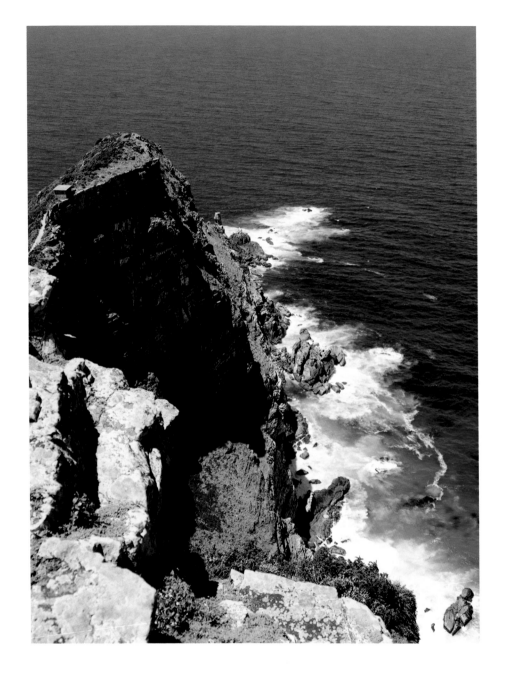

Sea lapping the rocky coastline at Cape of Good Hope, Cape Point

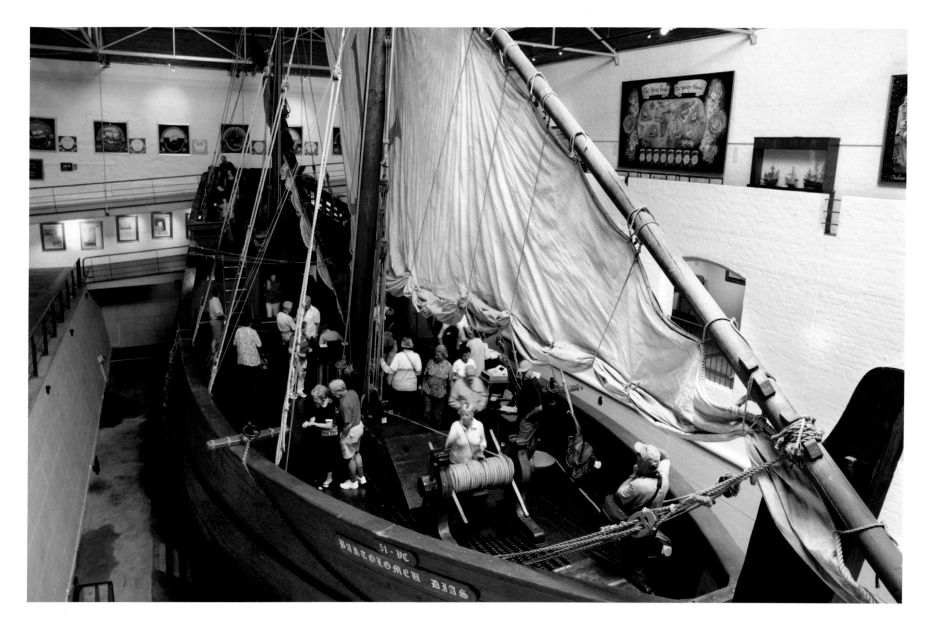

A full-sized sail boat is one of the displays inside the Dias Museum at Mossel Bay

Opposite: A white rhino grazing in Hluhluwe-Imfolozi Game Reserve, the location of Operation Rhino in the 1950-60s that was instrumental in bringing rhino back from the brink of extinction in southern Africa

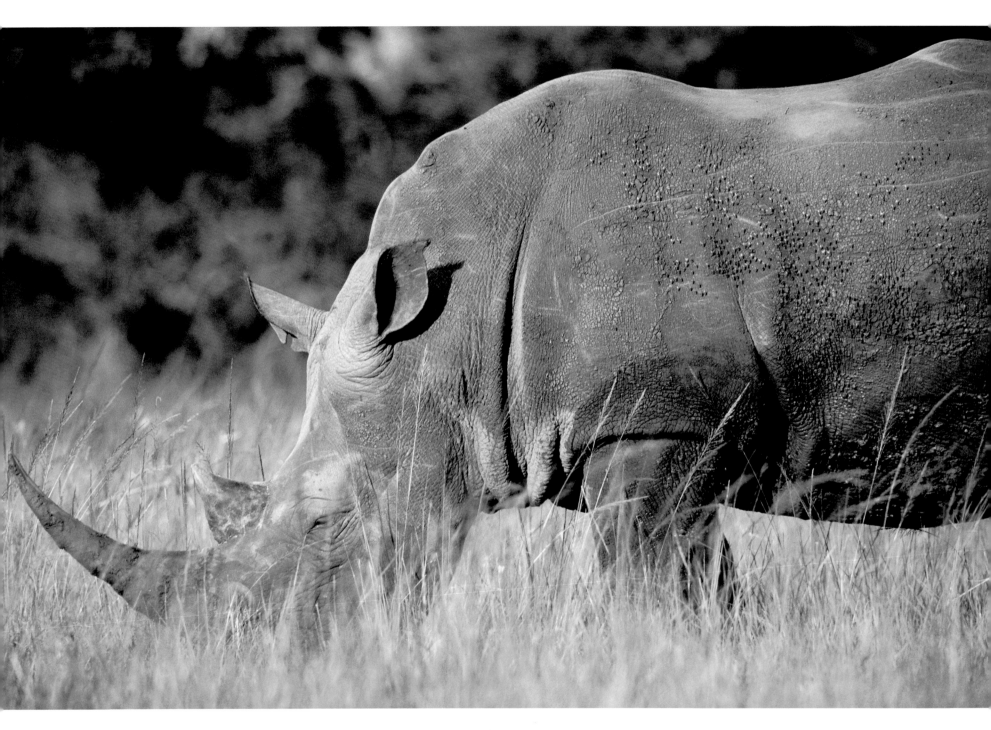

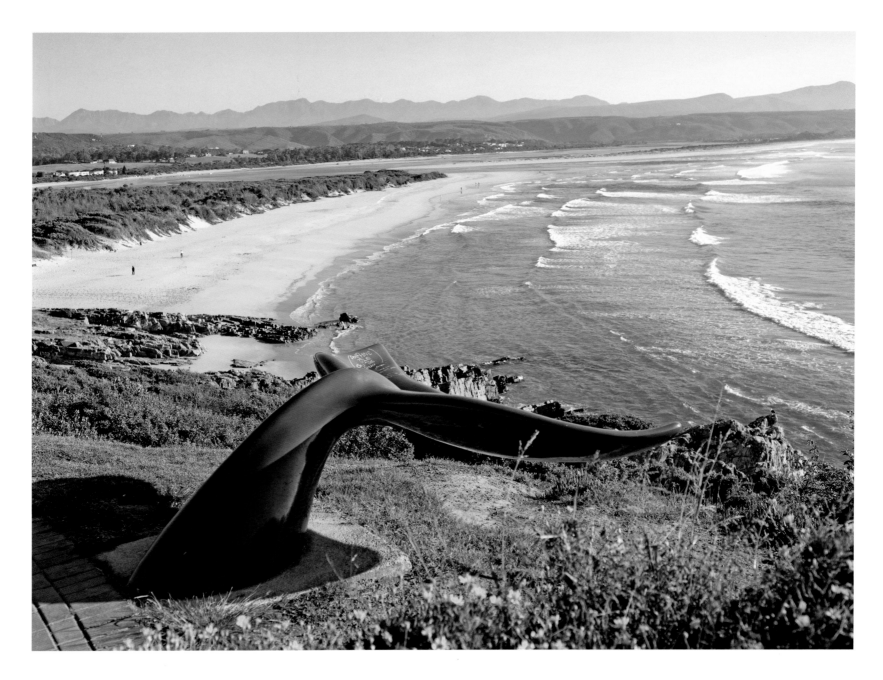

A whale sculpture above the beach at Plettenberg

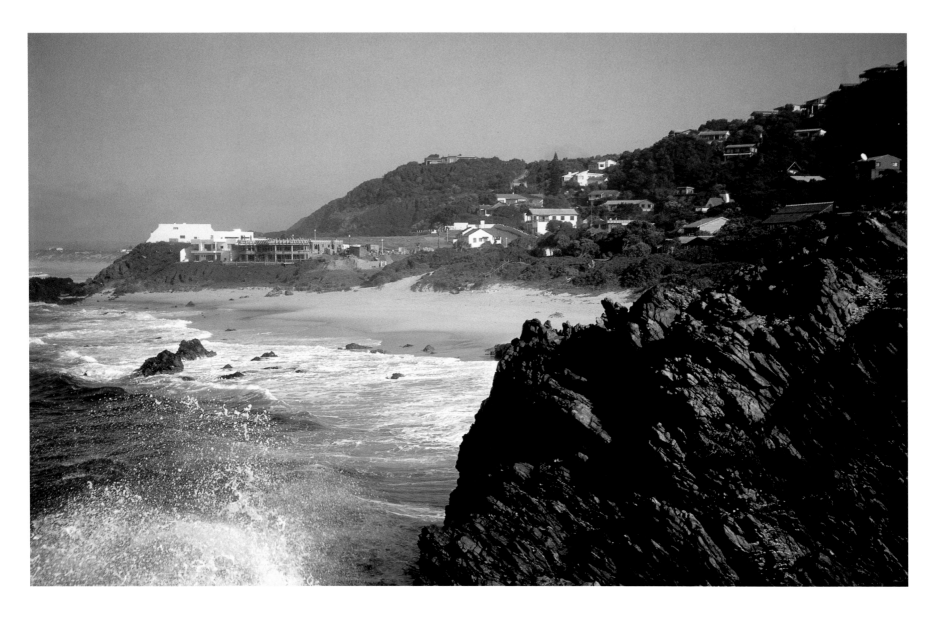

Keurbooms Beach near Plettenberg Bay, where dolphins can be seen on a daily basis and whales come into the bay to mate and calve in season

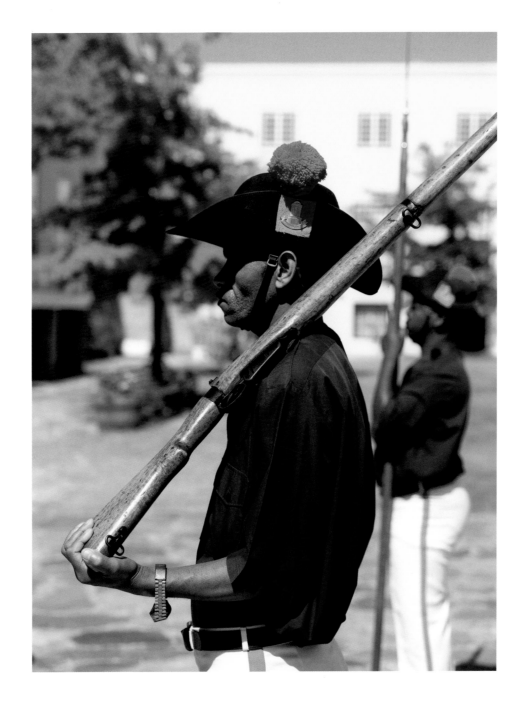

Guards at Cape Town's Castle of Good Hope during the Keys Ceremony

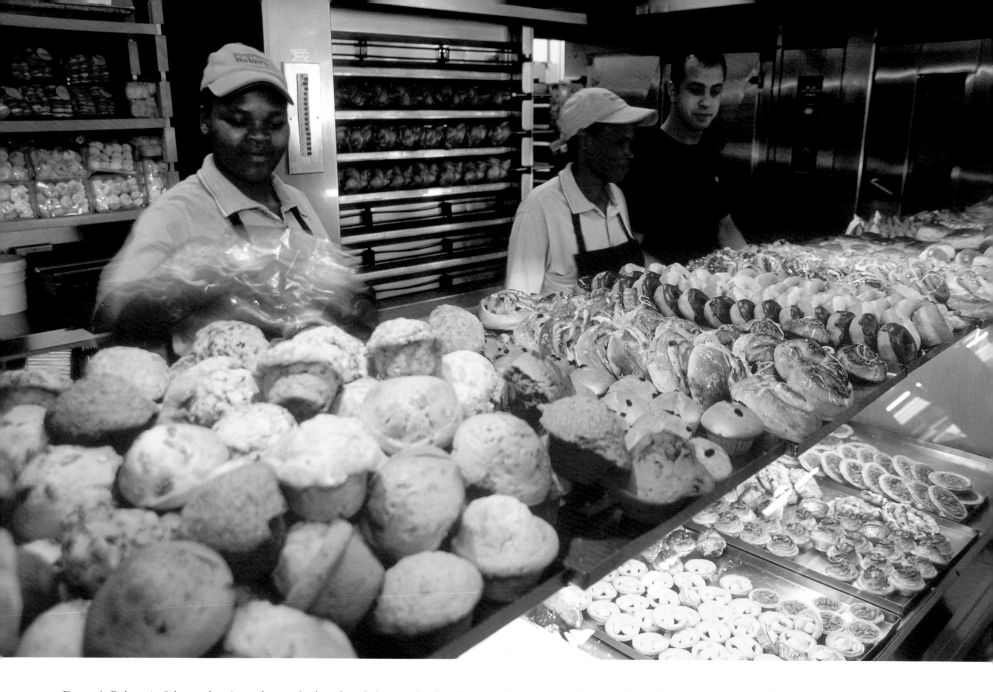

Fourno's Bakery in Johannesburg's northern suburbs, where bakers work all night to produce fresh pies, breads and pastries, and the outside tables are popular for business meetings conducted over informal breakfasts and lunches

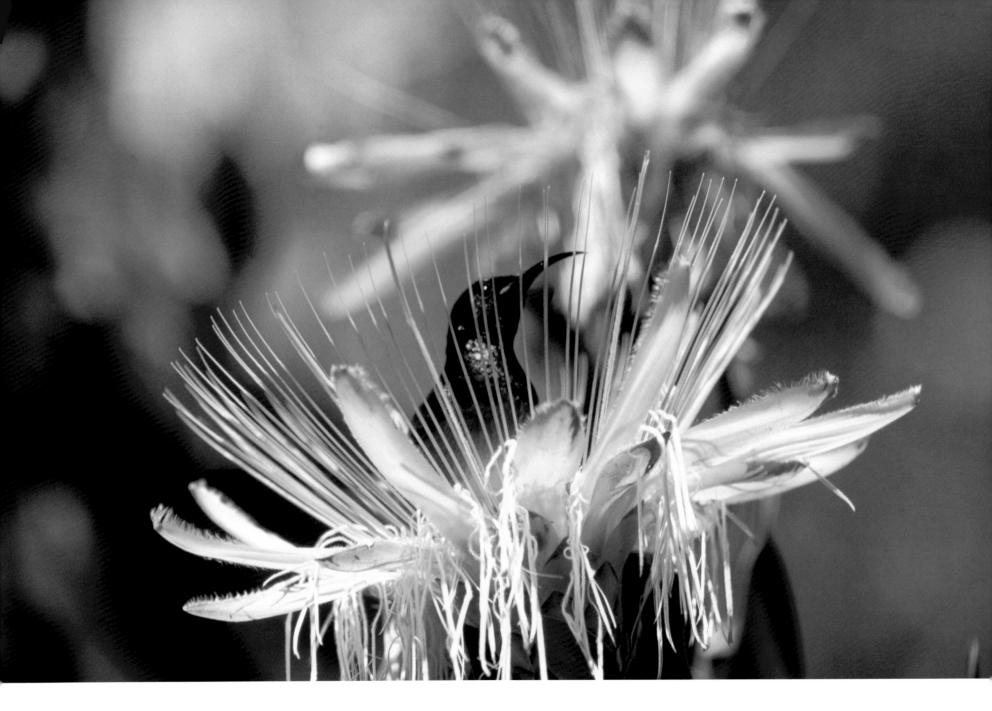

An orange-breasted sunbird feeding from a protea flower in Cape Town's Kirstenbosch, South Africa's oldest, largest and most exquisite botanical garden

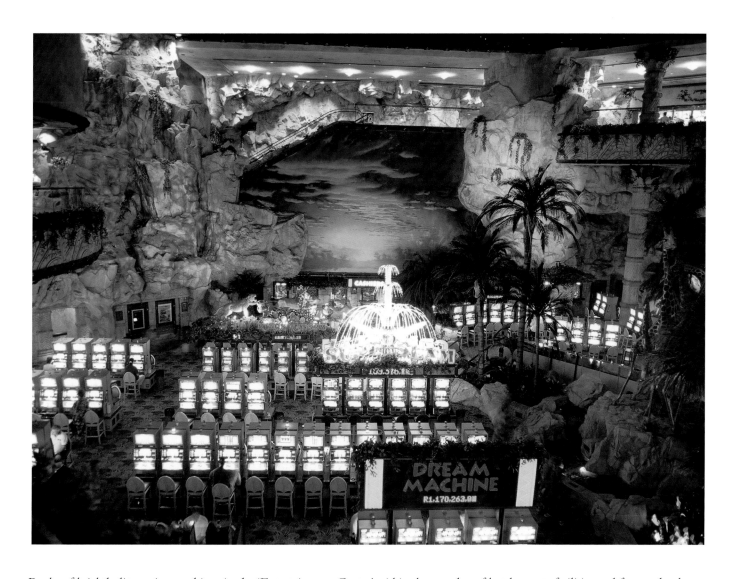

Banks of brightly lit gaming machines in the 'Entertainment Centre' within the complex of hotels, sports facilities and fantasy landscapes comprising the resort of Sun City in North West Province

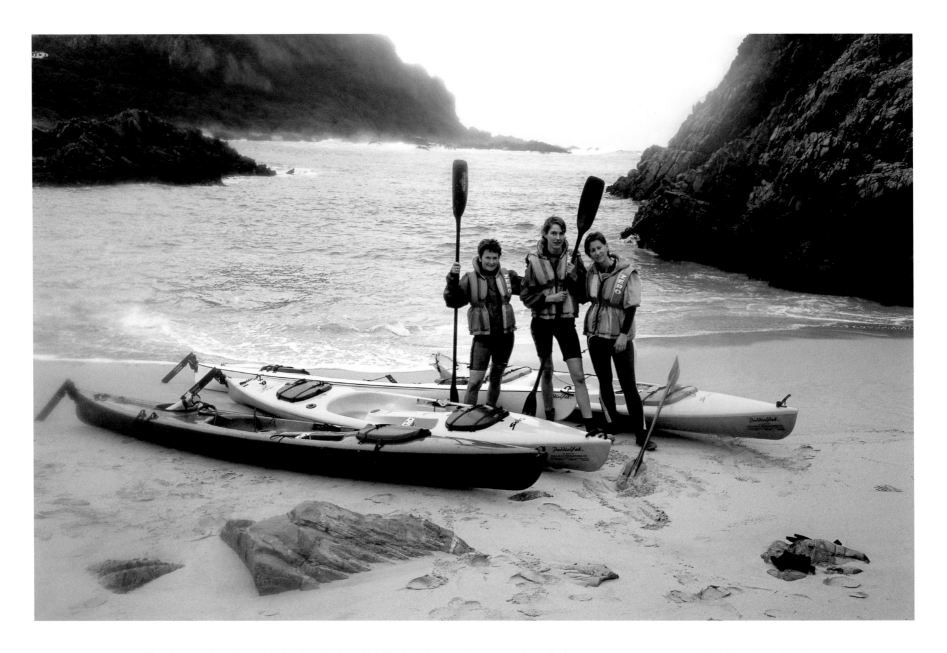

Kayakers ready to launch off a beach along the Garden Route, where a number of adventure sports on water and land can be enjoyed
Opposite: Colourful pink, orange and green exteriors to houses in Bo-Kaap, the Islamic quarter of Cape Town and home to the Cape Malay
community who are descended from slaves

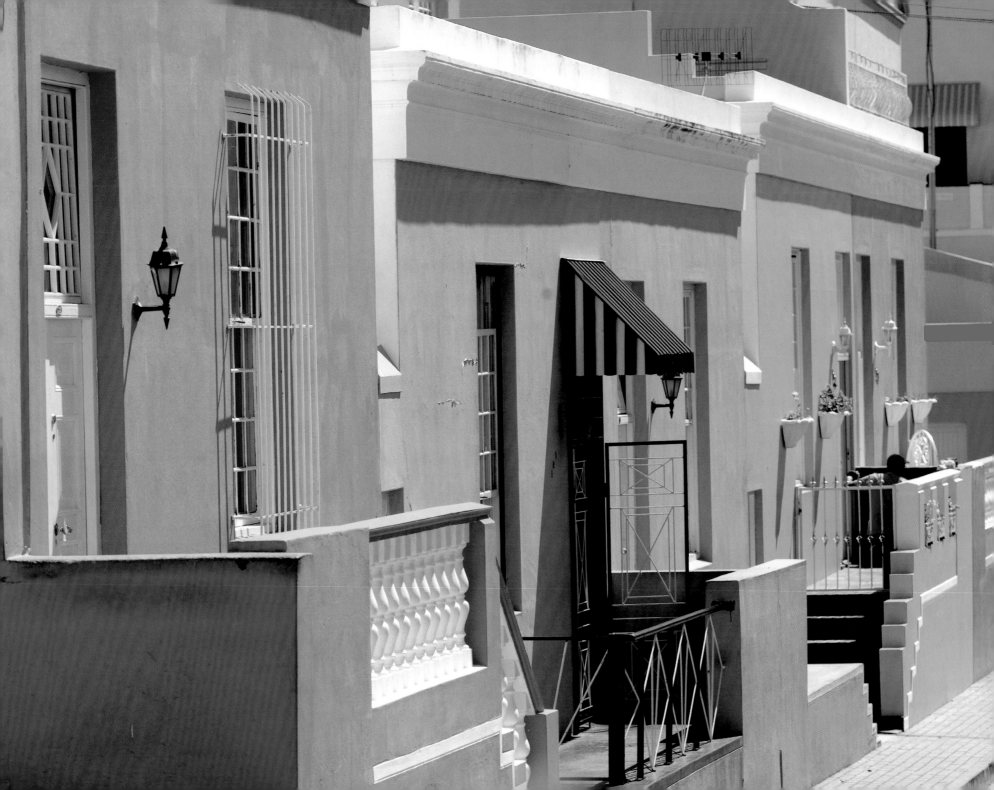

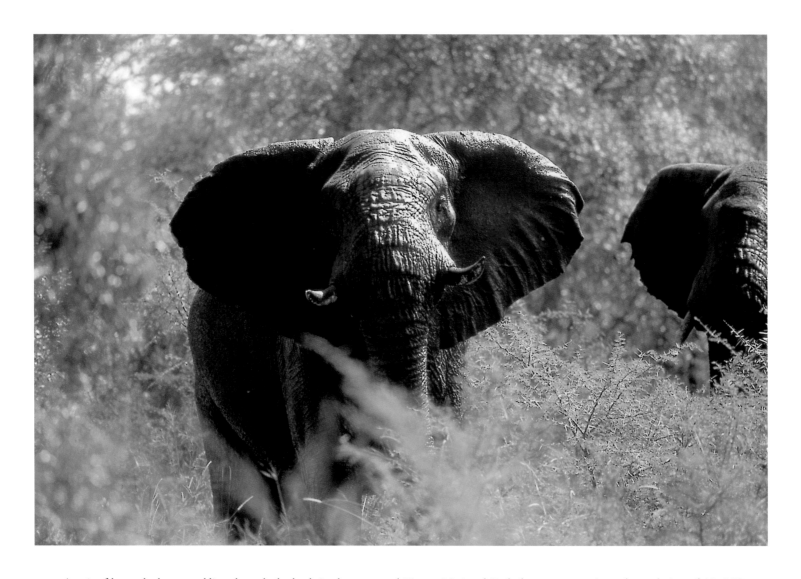

A pair of large elephants ambling through the bush in the renowned Kruger National Park, home to an estimated population of 12,000 elephants among many other species of animal

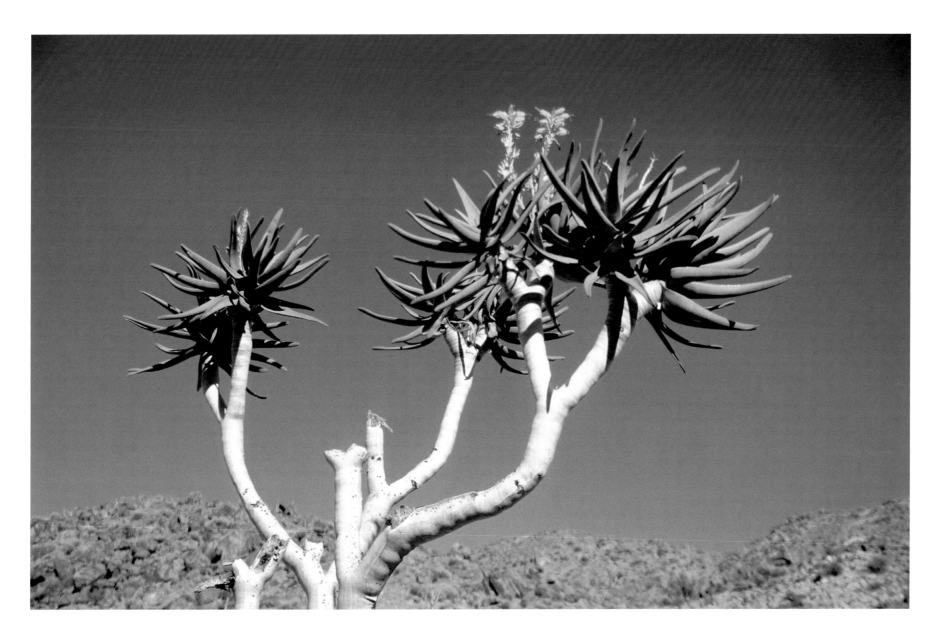

A quiver tree in the Ai-Ais/Richtersveld Transfrontier National Park, which despite a harsh and arid environment supports a rich desert flora and dramatic landscapes

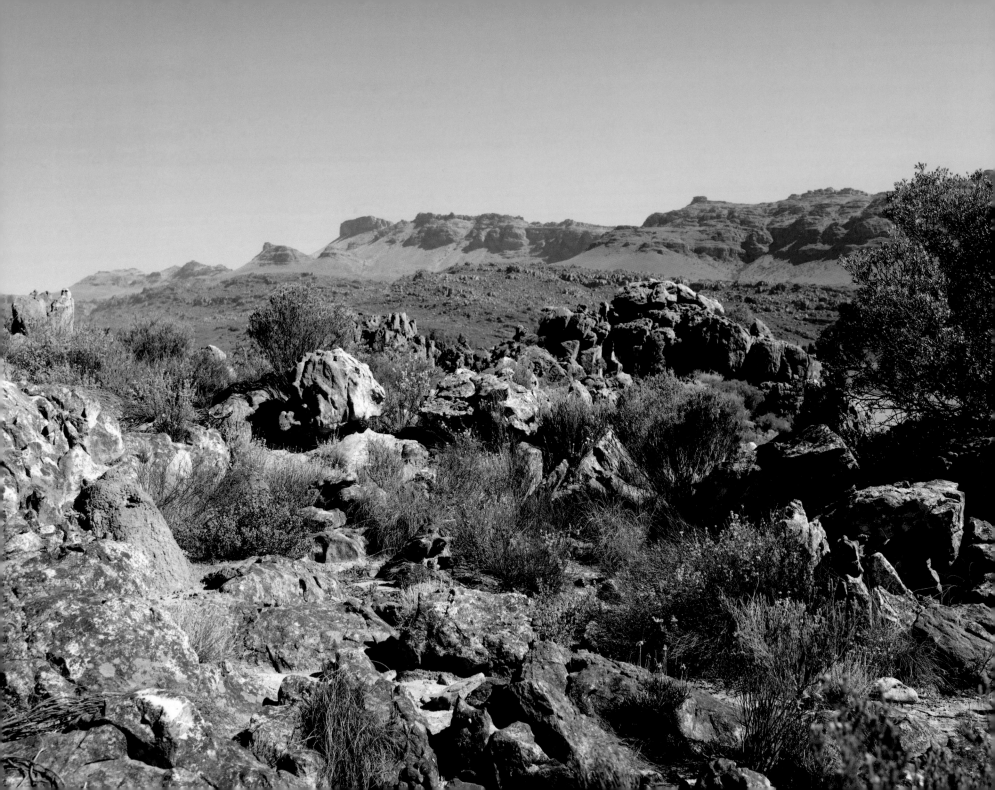

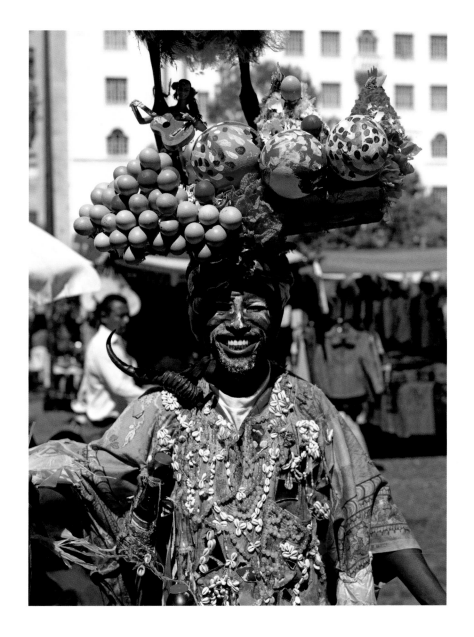

With his extraordinary headdress, painted face and undying smile, the Egg Man from Benin is one of Cape Town's favourite characters at Greenmarket Square
Opposite: The Cederberg Wilderness Area in the northern reaches of the Western Cape, famous for its rugged scenery and stunning rock formations

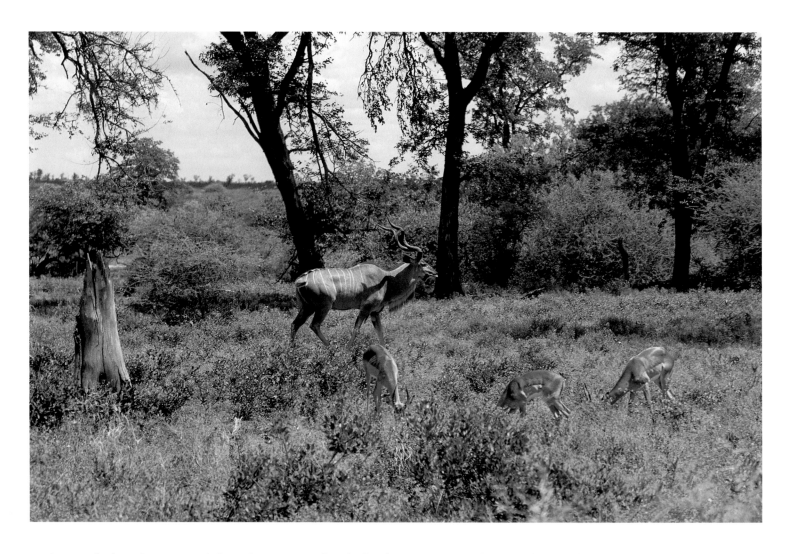

A greater kudu and some springbok in Kruger National Park after the summer rains, when new shoots and lush vegetation provide a surplus of food for grazers

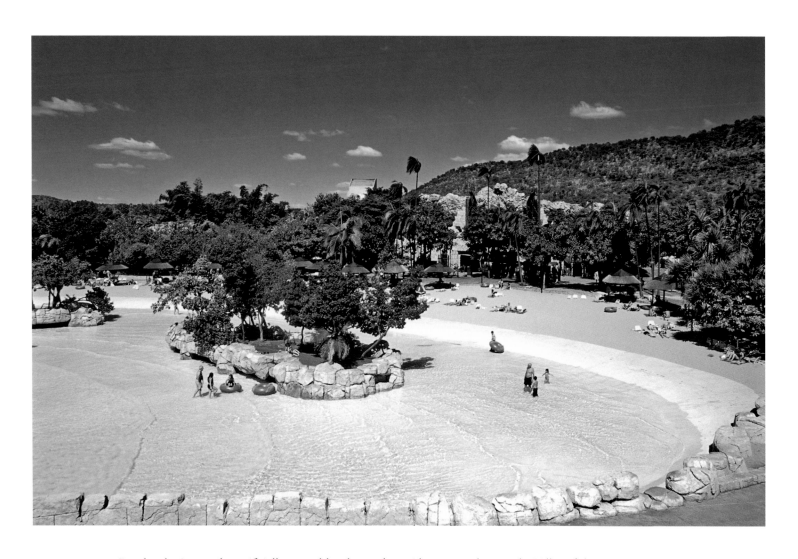

People relaxing on the artificially created beach complete with wave machine at the Valley of the Waves, Sun City

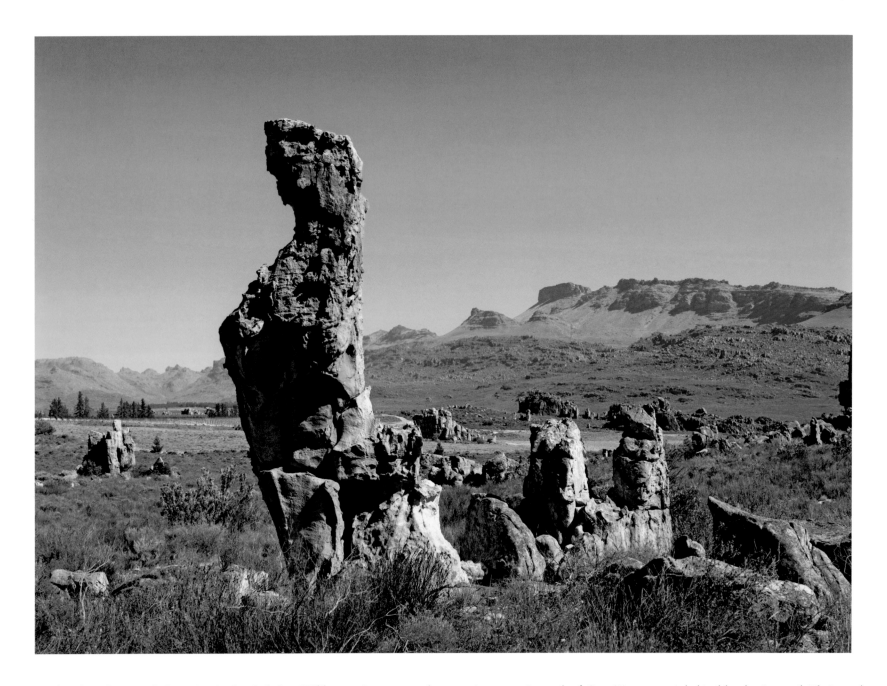

A weathered sandstone rock formation in the Cederberg Wilderness Area, a rugged, mountainous terrain north of Cape Town, once inhabited by the San and Khoi people

Colourful paintings for sale in Greenmarket Square, once a farmers' market and now a popular arts and crafts market frequented by tourists

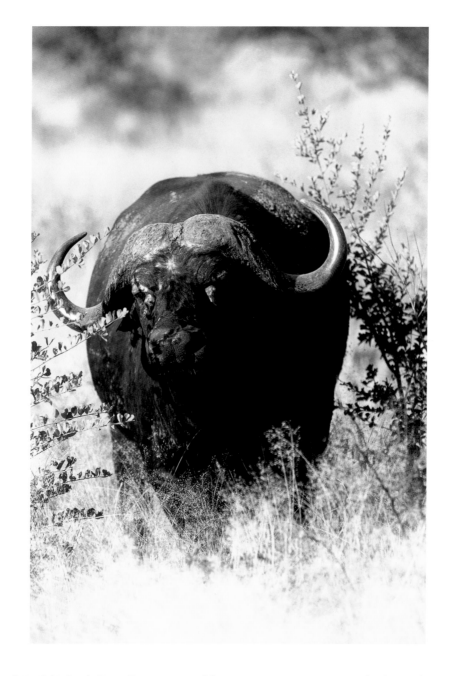

A buffalo emerging from the undergrowth in Sabi Sand Game Reserve, one of the many private game reserves bordering the western edge of the Kruger National Park

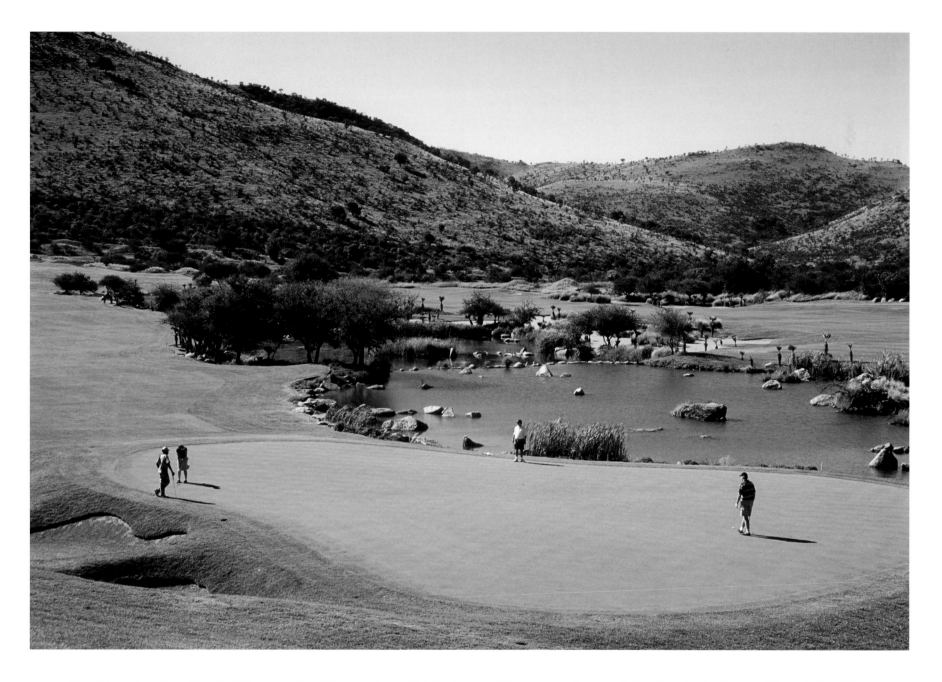

The Palace of the Lost City Golf Course at Sun City, one of two 18-hole championship courses at the resort designed by South African golf legend Gary Player

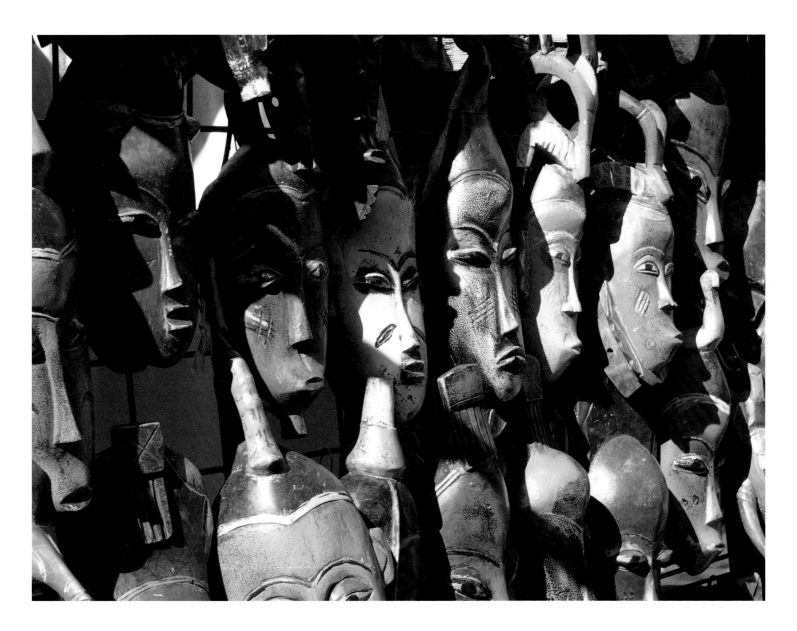

West African masks for sale at the market in Cape Town's Greenmarket Square, which sells curios from across the continent
Opposite: Knysna Lagoon, more accurately defined as an estuary, which has five rivers flowing in from the surrounding Outeniqua Mountains

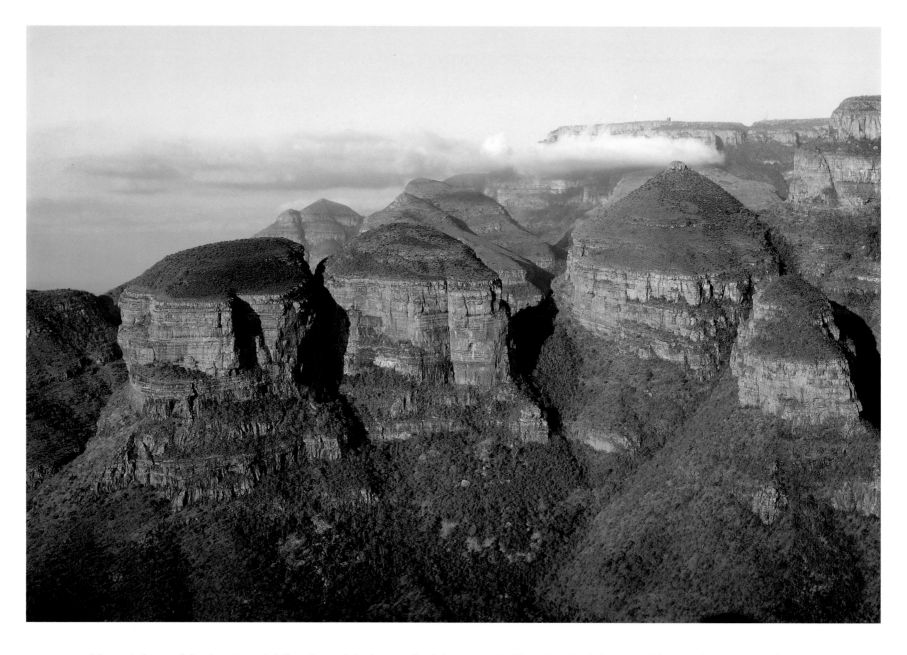

The conical tops of the sheer, jagged cliffs and rounded columns of rock known as the Three Rondavals because of their similarity to typical African circular huts, in Mpumalanga's Blyde River Canyon
Opposite: African Sacred Ibis in trees at McGregor in the Breede River Valley

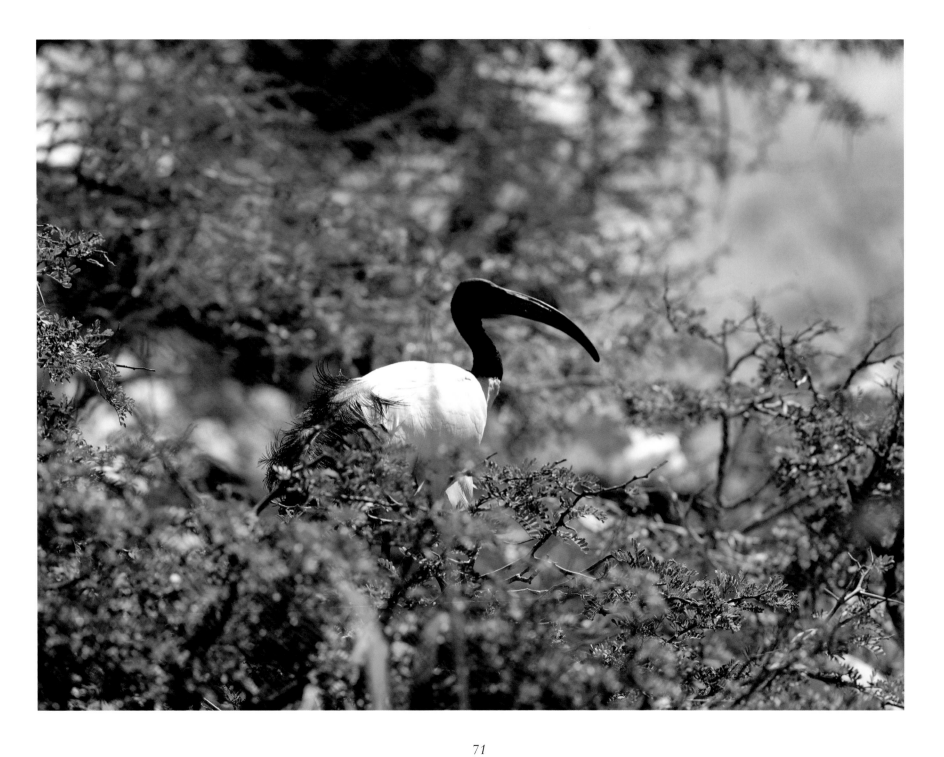

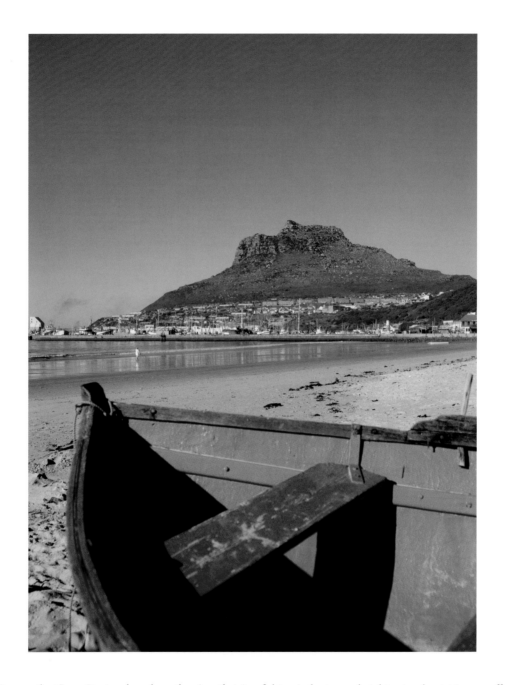

The spacious beach at Hout Bay on the Cape Peninsula, where there's a thriving fishing industry and sightseeing boat trips on offer from the picturesque harbour

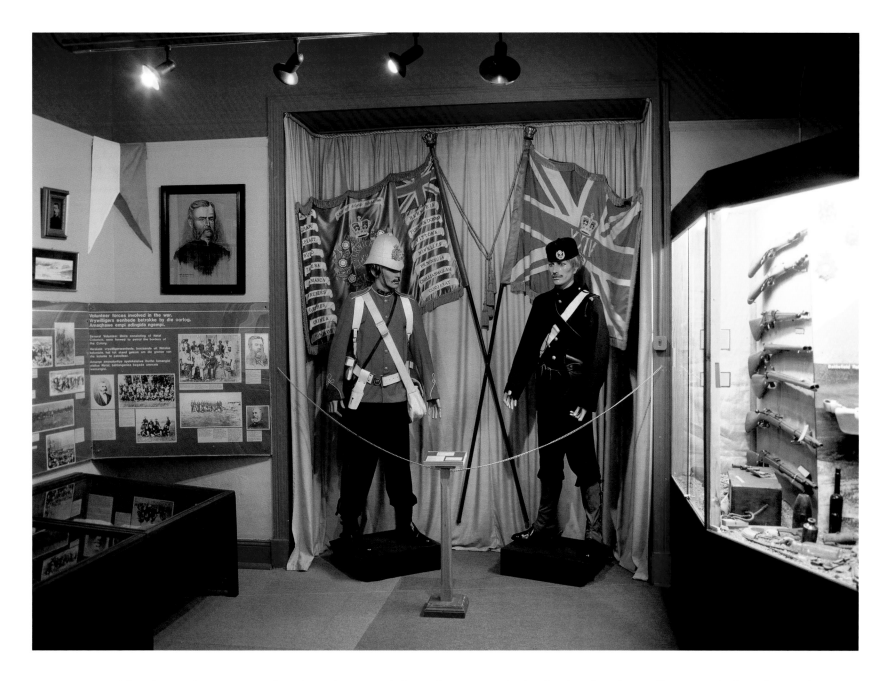

One of the tableaux depicting scenes from the Zulu Wars and the Anglo-Boer War, displayed within the Talana Hill Museum, built on the site of the battlefield just outside the town of Dundee

The tranquil Knysna Lagoon and river system, known as the Knysna National Lake Area, surrounded by indigenous forests and golden beaches

Spring blooms in Kirstenbosch, Cape Town's lovely botanical gardens that stretch up the eastern slopes of Table Mountain

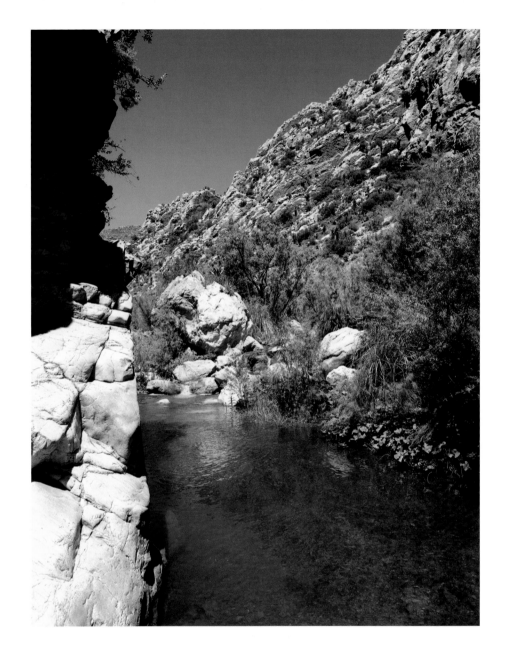

A rocky stream in the Swartberg Pass, a twisting, switchback road through the scenic Swartberg Mountains near Oudtshoorn
Opposite: The impressive granite Rhodes Memorial at the foot of Devil's Peak, Cape Town, dedicated to imperialist Cecil Rhodes who was Cape
Prime Minister from 1890 to 1896

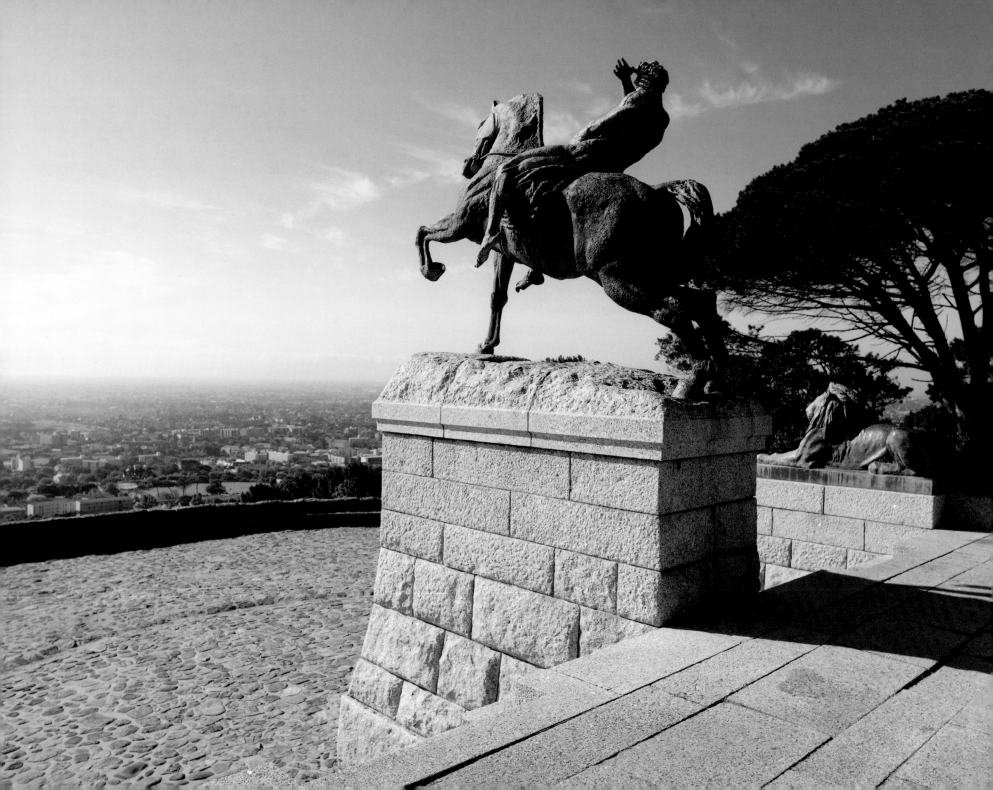

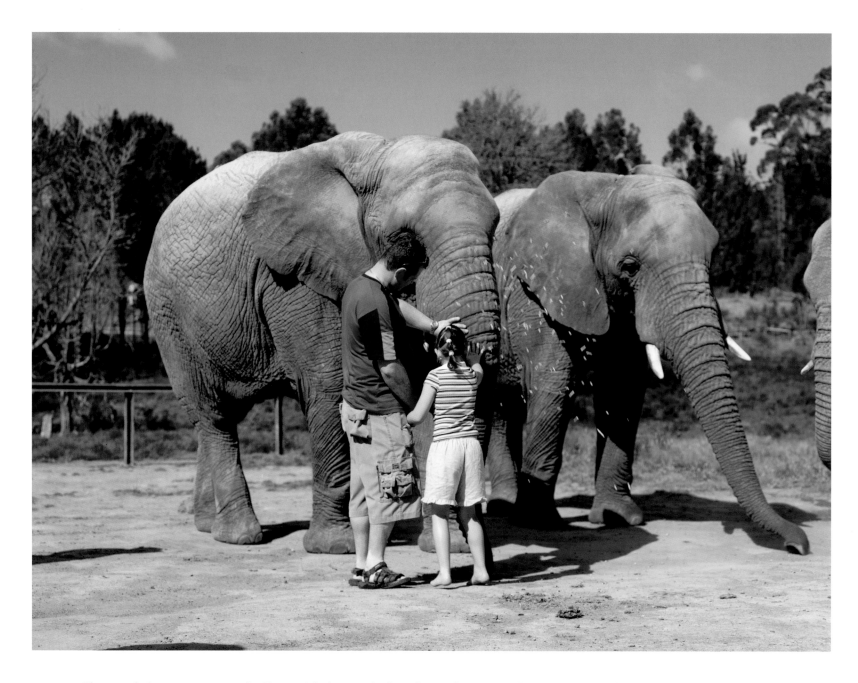

Close-up elephant encounters at the Knysna Elephant Park along the Garden Route, where visitors can walk with or ride the tame elephants

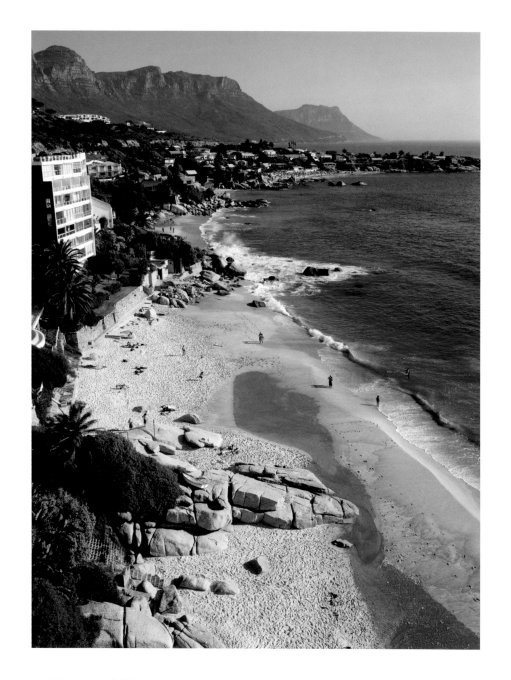

The four small and beautiful beaches of Clifton are divided by giant granite boulders and are the haunt of Cape Town's glamorous people

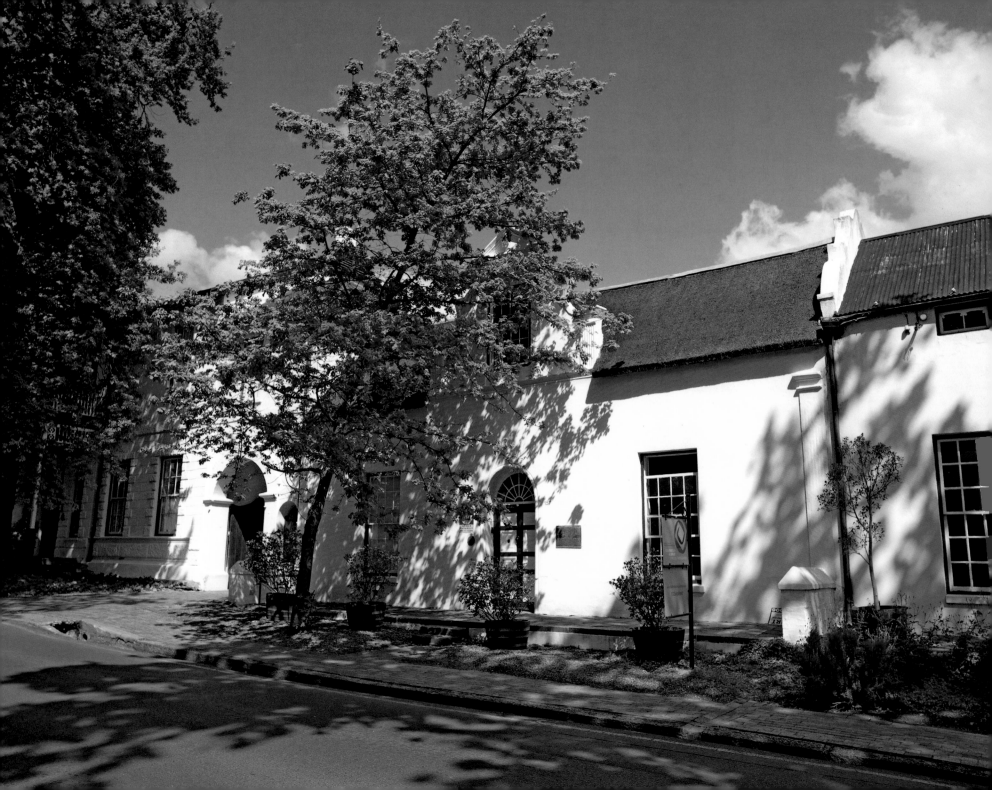

Yellow blooms growing on top of Table Mountain, Cape Town

Opposite: Dorp Street in the historical town of Stellenbosch has an avenue of oak trees and a number of carefully restored whitewashed 18th- and 19th-century buildings

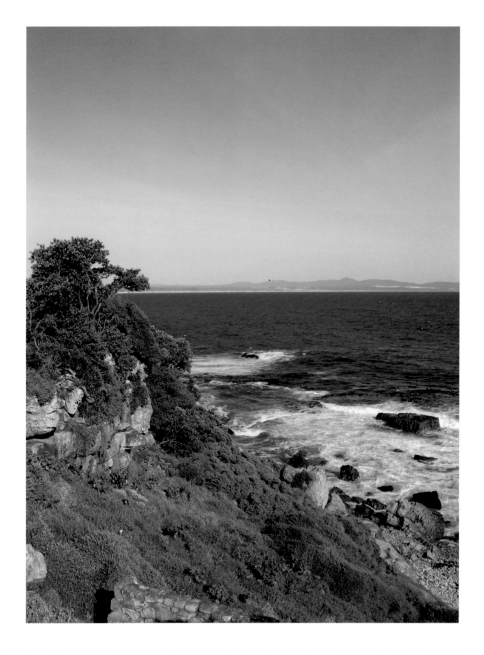

A view across Walker Bay from a cliff path at Hermanus, which is best known as the location for the world's best land-based whale watching in season from July-November

Opposite: One of the most evocative views of Table Mountain from the beach at Blouberg at sunset

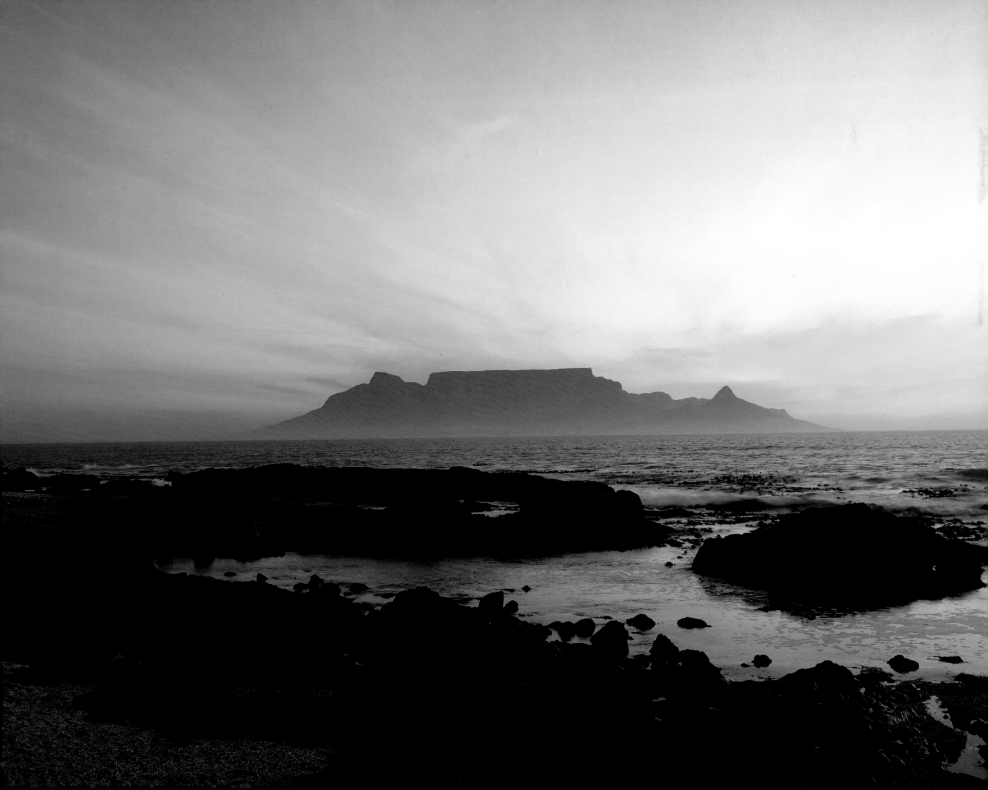

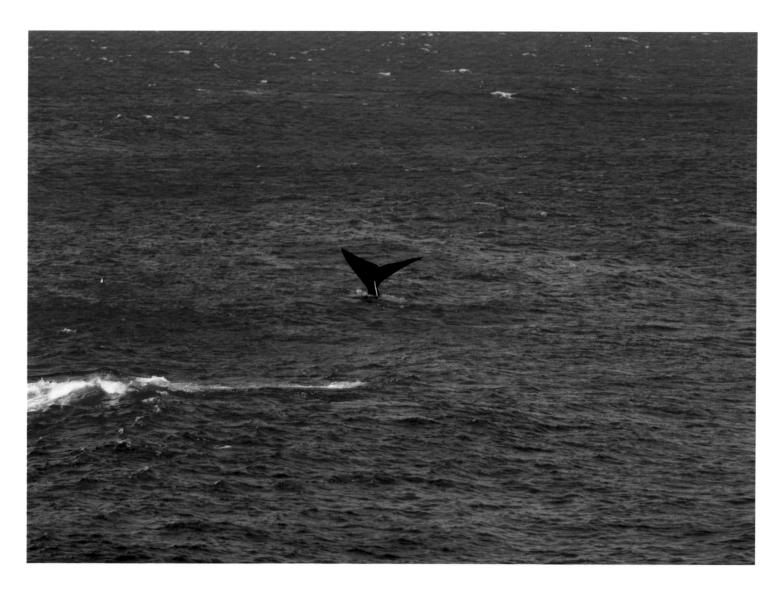

A whale in Walker Bay, Hermanus, where the combination of low cliffs and deep water offers the opportunity to see whales in close-up

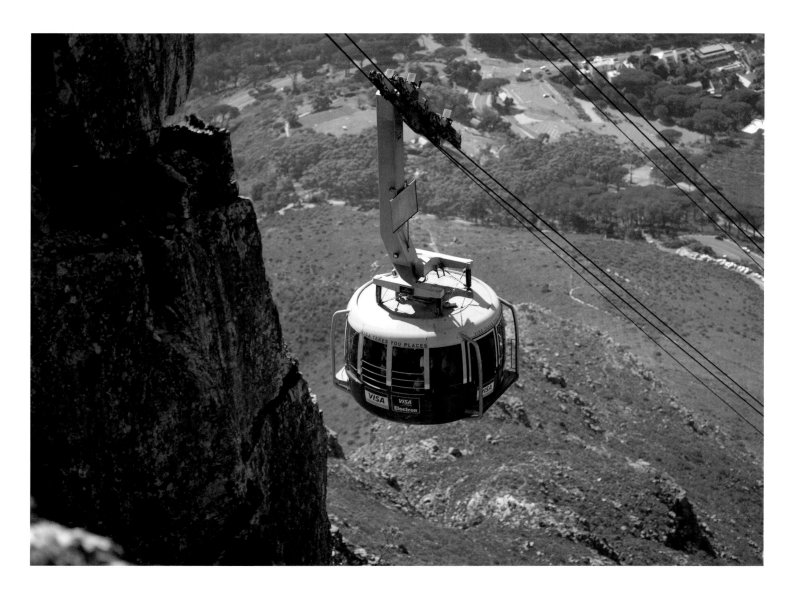

The dizzying trip to the top of Table Mountain in the Aerial Cableway is one of Cape Town's highlights

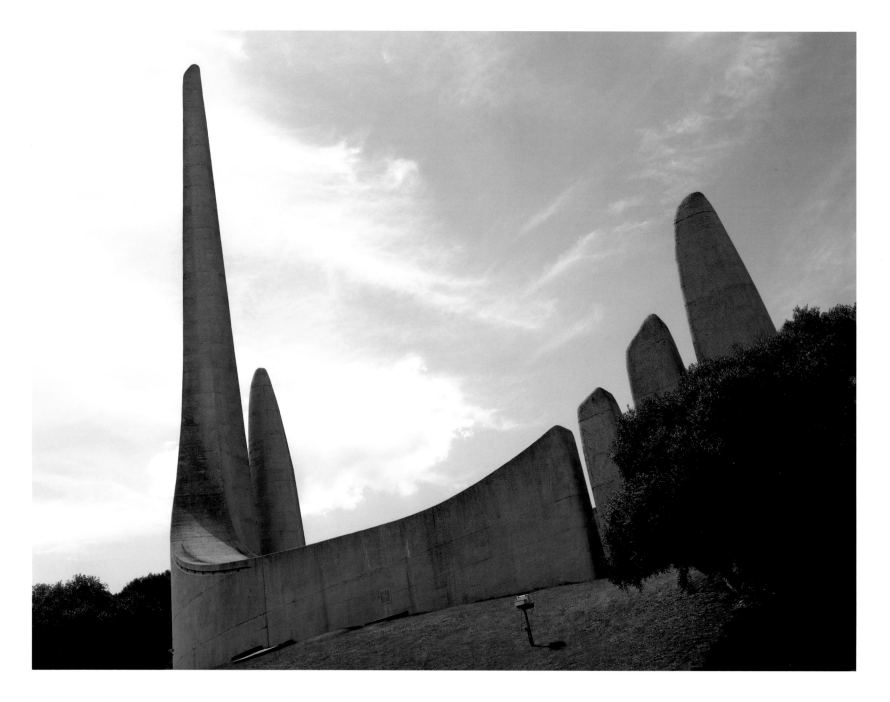

The Afrikaanse Taalmonument (Afrikaans Language Monument), with its three concrete columns linked by a low curved wall is set high on the slopes of Paarl Mountain

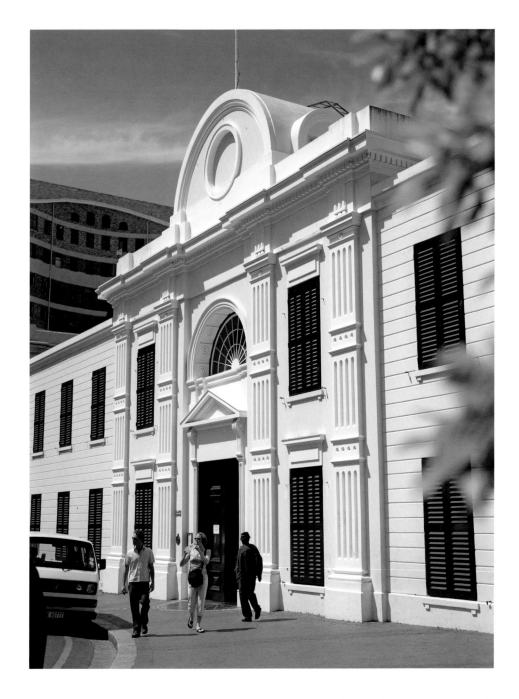

The main entrance to the Slave Lodge, once a holding cell for slaves in the 1700s and now a museum dedicated to how slaves contributed to establishing the city of Cape Town

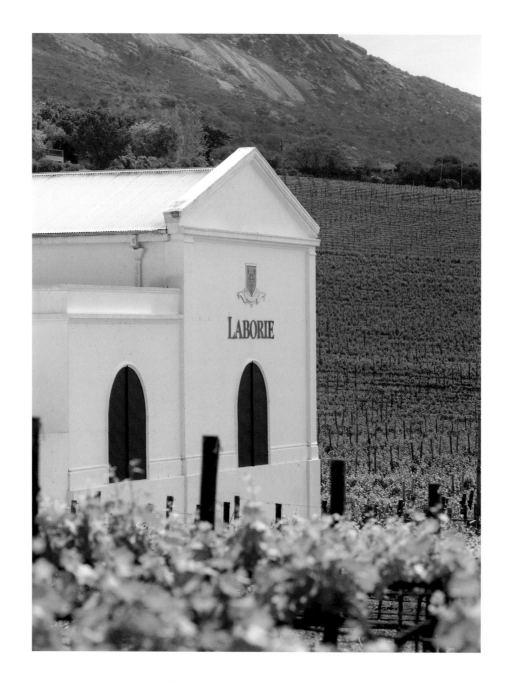

The historic Laborie Wine Estate in the heart of the Paarl Valley
Opposite: Wine crates in the Vaughn Johnson Wine Shop on the Victoria and Alfred Waterfront, Cape Town

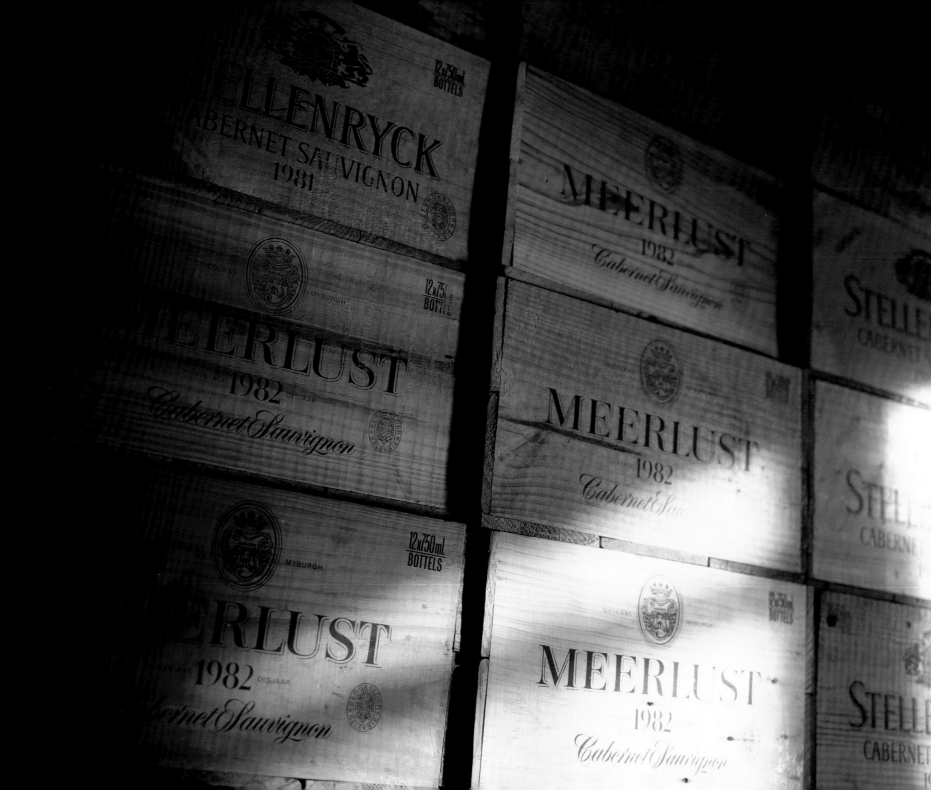

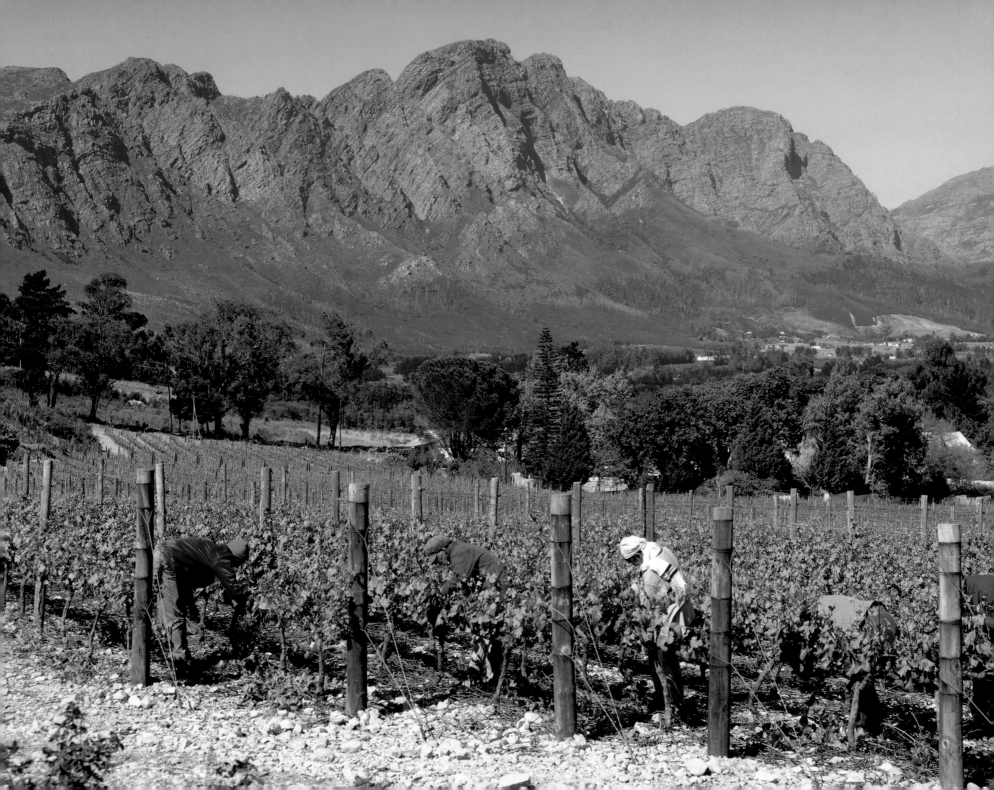

Exterior detail of the South African National Gallery on Government Avenue in Cape Town, which is home to both classical masters and contemporary art
Opposite: Grape harvesting in the beautiful Franschhoek Valley, studded with original French Huguenot estates that can be visited on the Franschhoek Wine Route

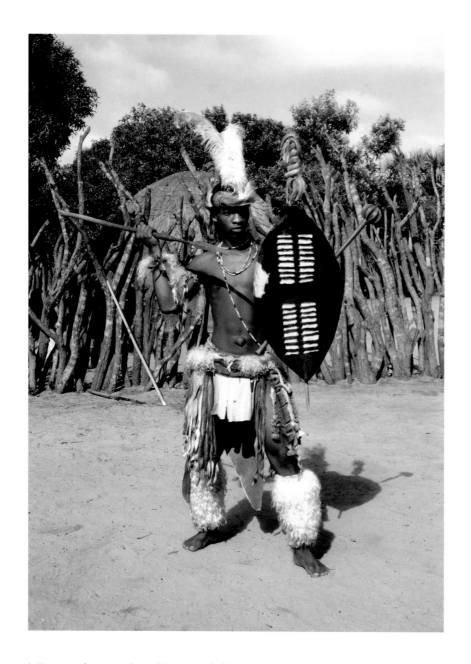

A Dumazulu man, dressed in animal skins and posing with an oval shield and spear, in a tribal village in Zululand with a fence fashioned from branches in the background

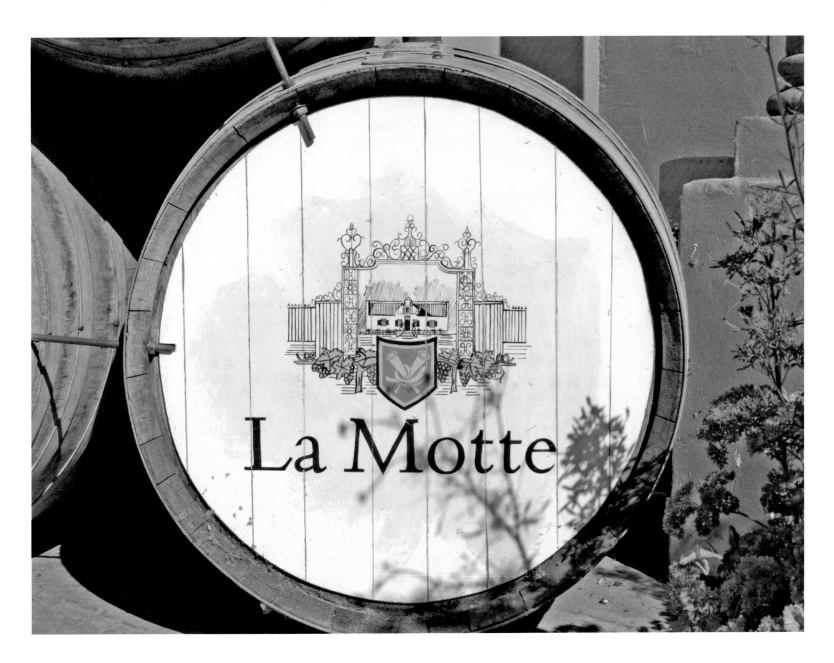

A wine barrel from the La Motte estate, one of the many in the fertile Franschhoek Valley

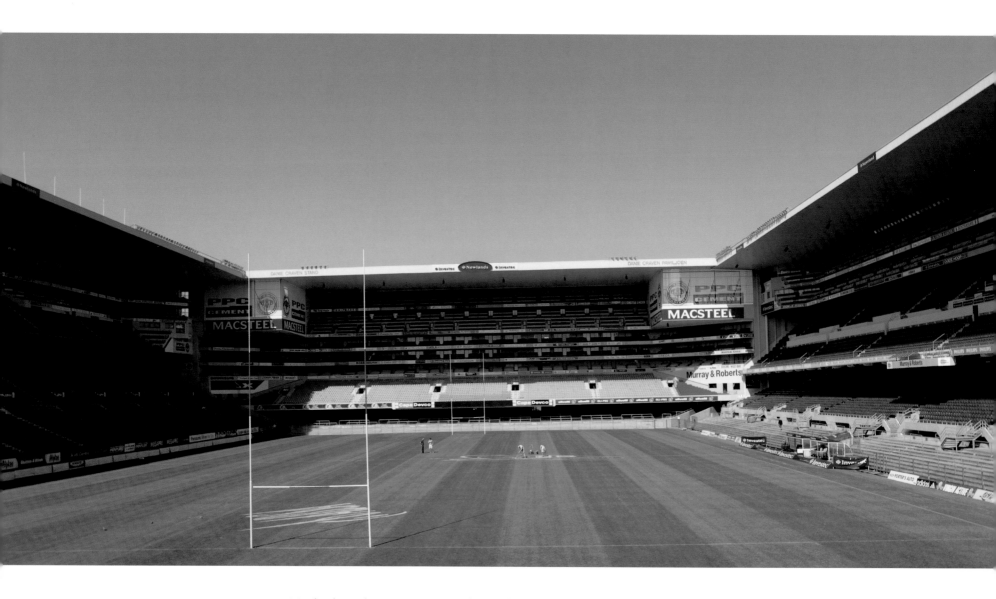

Newlands Stadium in Cape Town, home of the Western Province Rugby Football Union

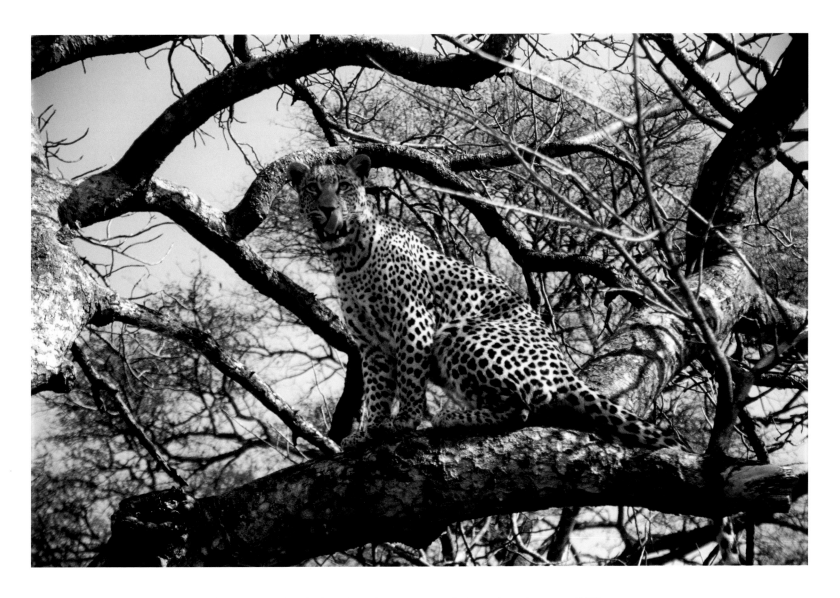

A female leopard in the branches of a tree in one of Mpumalanga's many wildlife reserves

INDEX